judith.smith@ unb.edu

YOU'LL LIKE THIS FILM BECAUSE YOU'RE IN IT: THE BE KIND REWIND PROTOCOL

MICHEL GONDRY

You'll Like This Film Because You're in It:
The *Be Kind Rewind* Protocol
Michel Gondry

A PictureBox Book

Editor and publisher: Dan Nadel
Design: Helene Silverman
Assistant Designer: Max Pitegoff
Photography: Camille Setier, Jordan Kinley
Copy editor: Sam Frank

Deitch Projects staff: Gabrielle Shaw, Alexia
Tsotsis, Emily Lacy, Tim Schumacher,
Marina Noelle Byquist, Charlotte Schioler

Thanks to: Raffi Adlan, Jeffrey Deitch, Jasmine
Levett, Charles Wittenmeier, Meghan Coleman,
Marlene David, Britten Kinley, Will Luckman, Max Kelley,
Raymond Sohn, Jon Vermilyea, BeBe Lerner

PictureBox
121 3rd St.
Brooklyn, NY 11231
www.pictureboxinc.com

www.michelgondry.com

Available through D.A.P./Distributed Art Publishers

Printed in Canada

You'll Like This Film Because You're In It: The *Be Kind Rewind* Protocol

Michel Gondry

Research and additional text by Jordan Kinley

PictureBox, Brooklyn

Introduction Ask anyone point-blank to step in front of the camera and act, and you will face the same negative answer, unless the subject suffers from compulsive exhibitionism or has personal ambitions in the entertainment department. Now ask the same person to propose a film genre, then a possible title, and his engagement will be immediate. I have tried to find a system that, if followed, would provide a smooth transition between those two questions, transforming the embarrassment of ridiculing oneself before the lens into a joyful compulsion.

I developed and tested this system in March 2008 at the Manhattan art gallery Deitch Projects, which kindly transformed itself into a mini film studio where anyone could come with their friends to create a little film from scratch in two and a half hours. In just one month at Deitch Projects, more than one thousand people of all ages and social backgrounds shot 122 personal films of ten to fifteen minutes each. Together with Deitch, we provided cameras, sets, and a step-by-step protocol inspired by my experience shooting my 2008 film *Be Kind Rewind*.

In order to provide a minimum number of restrictions and a maximum amount of creativity and fun, the protocol consisted of two workshops in which participants followed instructions that guided them as they brainstormed ideas, created a storyline, and then planned out the other various narrative and production details. I worked very hard to find the best balance to stimulate everyone's imagination and avoid inadvertent domination of the creative process by stronger or more compulsive members of each group. Basically, the rules were devised to allow the community to be the leader.

After preproduction and filming, the process culminated with a group screening of the completed film. Each time, it was a mini-celebration, and numerous times I witnessed the happiness, pride, and, of course, laughter that come with self-recognition onscreen.

The miniature film companies were usually composed of friends who arrived together, but outsiders often joined up, and by the end of the shooting process strong connections were formed between complete strangers. It was also surprising to realize that this activity (that's the best way to describe the process) had allowed kids to interact creatively with adults without any kind of parental supervision. Young children were participating in the invention of stories at the same level as adults. In modern society, especially in the United States, these types of interactions are so overcontrolled due to fear of abuse, etc. that it could be argued that the protocol is one of the only contemporary ways to allow child-adult creative interaction in a safe, noneducational environment.

But our story begins in my own childhood, in another environment entirely...

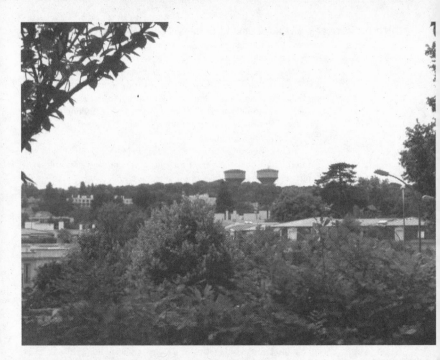

1 | From the Suburbs to Paris: Culture and Abandoned Theaters

In 1983, my mother moved to the mountains. Some invisible spiritual guides told her through the voice of her peroxided friend that in the years to come, the level of the sea would rise and big cities like Paris would be flooded. At the time, we were living in a small suburban house in Versailles, a conservative town plagued by hordes of old families wearing the same green loden from generation to generation. Mom sold the house in Versailles, and my brother Olivier and I, helped by our divorced father, found a three-room apartment on rue Labat in the 18th arrondissement in Paris, like in the Edith Piaf song. Closing the hatch of the rented little van over my mattress is the very last image I keep of my first twenty years of life.

Until I closed that hatch, my family had only ever lived in one home. I still visit and rebuy that place every night in my dreams. I generally call my brother (from the dream) to tell him the great news: "Guess what? I just bought the Versailles house. Mom is there already. Come with us. We are getting the family back together." I am childhood-traumatized. Our house stood next to the edge of the forest, where two water towers emerged in the distance. I always believed they were just two big concrete rain catchers hanging on the canopy, so I was dismayed when I discovered that they were actually attached to the ground. Those were my youth landmarks, besides Parly 2, the first big European mall which opened in 1969.

In Paris, there were no water towers or malls in sight. More like Indian music, African wigs, and dried fish all at once. Stores, fast-food chains, cheap furniture shops, and lots of cars. And cinemas too. But not cinemas that screened movies; cinemas that sold shoes or food or music for gay people, like the Louxor. One day by chance I ran into my eighth-grade best friend, Alain, whom I hadn't seen since our time in grade school. Alain ghostwrote my first essay for tenth-grade French, earning me the best grade and the private humiliation of reading aloud to the rest of the class a text I had not written. Alain said he was working as a Madame Pipi at the Louxor. The Louxor was one of the most prestigious movie theaters in Paris until it closed in the 1970s. The 18th arrondissement was once bursting with film theaters—even small theaters—until they all closed down to make way for the multiplexes. Because the inhabitants of the district were mostly immigrants and old ladies, the business owners didn't bother to adapt the architecture they inhabited to their actual trade. Instead, they would just move in and only change the neon signs, so you could clearly see what they used to be.

Seeing these converted cinemas triggered a sweet utopian idea that began to tickle my brain.

See, my dad used to call me a communist when I was trying to make a point about my embryonic philosophy of sharing versus preserving unique privileges. He said that capitalism was the way nature works and no matter how much we fight it, we will always fall back into it, so we'd better get used to it. I was secretly proud he called me a communist, and the more I passed by those recycled landmarks, the more I began to think of a system that could put them to better use.

What if a camera—either video or film (at the time I was probably thinking film)—was given to a group of neighbors who all

lived near one of the theaters? They would shoot random footage of themselves and their friends; perhaps some films would be fictional narratives, while others could be more unstructured. But most important, the films would be about the people who shot them. Each film would be roughly edited and screened in the theater over the weekend. People would pay the price of a regular movie ticket, and the money collected would finance the next shoot and pay for the rent of the cinema. The whole cycle would last one week. I know, the numbers don't add up. I just realized that when I wrote the word "rent." I guess I was counting on having the theater for free. The Louxor, for instance, has been empty since the mid-1980s: absolutely abandoned. Yet this is how a utopia defines itself, at least for me: It's something that is not supposed to happen outside of your mind, like sleeping with the girl you are in love with. Sorry, that's not the subject. Besides, a utopia is an imaginary city. But ideas are like cities: Once they are started they keep on building on themselves, accumulating incongruous layers over the years to form a complex texture resembling organic matter.

But I believed people would really enjoy these screenings. Not because the films would be anything particularly special in terms of entertainment value, but simply that they would love the film because they were in it. And their friends, and their family, and the streets they walk on every day, and so on. Exactly like a home video, only a neighborhood video.

Producers always tell filmmakers that the audience wants to recognize themselves in the protagonists, yet the actual life of a famous film actor couldn't be more distant from the lives of the audience. It's the same thing with the landscape and sets in a film. Most people don't wake up in the morning with a palm tree in front of their window, a blue sky, and the L.A. smog. Everybody's life is unique, and so is everyone's environment. However, at the core, the producers are right: People want to see themselves and identify with what's on the screen. Maybe there's a principle of resonance, like in physics, that produces an emotional satisfaction, or simply the feeling of not being alone. Or even simpler, people noticing our existence… I knew people would enjoy my idea. It was a perfect self-sustaining system. More people would participate each week, and more tickets would be sold each weekend. Nature likes self-sustaining systems. That's a criterion in natural selection. You hear me, Dad?

But all of that was happening only in my head. I don't think the idea even made it into one of my messy notebooks. I have a lot of naive concepts to make the world better. For example, I'd like to brand the word *information* and only let a television network call its news "information" if the network respected a chart carefully established by the hundred most respected reporters on the planet. Or to compensate neighborhoods ravaged by freeways by creating commercial and social constructions at equivalent surface proportions. Lots of possibilities…

But soon after my utopian idea, I began to work at an animation studio painting dots on wallpaper for conservative children's stories. I had my band, Oui Oui, and eventually I directed its videos and slowly forgot about my utopia.

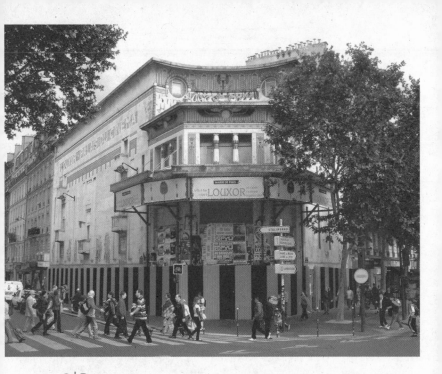

2 | Dave Chappelle and the Concept of Community

Twenty years later, the comedian Dave Chappelle asked me to direct a documentary about a concert he was organizing in honor of his musician friends who had been faithful to him since before the success of his TV show. It was to be a celebration of his community. I first thought, "Wow, why is he asking me, a white French guy coming from a white nondescript French suburb, to direct a tribute to his musical community?" I felt suddenly important, at the top of the mountain. But wait a second. I knew what had happened. He had asked Spike Jonze, who was probably too busy. Yes, 100 percent sure that's what it was.

Anyway, sometimes being the second choice is better than straight-up rejection, so I acted like a first choice. Wait, now guilt was waiting around the corner: me, a white director, about to steal the potential job of a black director? Now it was the image of another Spike that came to poke at my legitimacy. Lee, that is. Well, Dave asked me, so I figured I just had to do an honest job and try to shoot in a decent fashion what all these people had to say to the world. And I guess try to understand them in the process. That was the harder part. I didn't see it coming, but when I started the project my comprehension of English dropped from 45 percent to 7 percent. That's 93 percent of comprehension that I had to pretend: a constant head nodding with an occasional vague expression of agreement for good measure. And every time the conversation would take a sharp turn, my brain would continue straight ahead at full speed and smash into a wall of abstraction.

People who share time, cultural influence, and sometimes

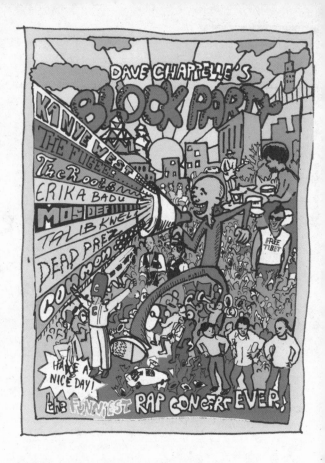

a background use shortcuts to communicate with one another, like my brother Olivier and I: We are always mumbling to each other. Probably because each time one of us starts a sentence, the other knows exactly how it's going to finish, so the first one, knowing that the second one has understood the sentence, doesn't bother to finish it. He just mumbles it to act as human as possible. On that note, I would like to sidetrack you with a simple theory I developed while trying to communicate my ideas during my shoots: When you give instructions to a colleague for a task you need done, you must try to condense all the important information into the first sentence, because that's the only one he will listen to. After the first sentence, the colleague will nod at sensible points, giving you the impression he is listening, but in fact he will already be trying to solve in his head the problem exposed in the first sentence. All the information provided in the following sentences will be lost to oblivion. Worse, you will believe wrongly that the information is actually being absorbed. I ran into so many communication problems until I discovered this phenomenon that I thought it would be a nice gesture to share it at this juncture.

End of digression. In this ongoing misunderstanding, I had only one advantage: Dave and his friends didn't understand a single word from me either. And yes, I was speaking a sort of English. It gave me a slim 7 percent lead over them. I remember the first conference call with Dave and all the bands: Kanye, Dead Prez, Mos Def, the Roots, Jill Scott, et al. I gave them my salesman speech for ten minutes, and then silence. Erykah Badu broke it by saying, "I didn't understand one word of what he said, but it must be good, because he's French and they have Chanel over there." Dave then had to repeat my whole pitch. He was used to my accent by then. For some inexplicable reason, a film eventually emerged from the multilayered and multicultured chaos.

The magic of Dave; the emotion of the Fugees reunion; those golf kids who were called the n-word because they peed on the court; the marching band from Ohio jumping in excitement when they found out they could come to Brooklyn for the concert. All of the images that went into the camera and the many more that went into my head tapped into a territory that I had never dared enter until then: people. More people than one or two. Groups of people. Community.

Many times I heard, "This concert is about the community." What community? African Americans? Rappers? Rappers with a message? Nostalgic rappers? Nostalgic rappers with a message? Wow, this whole community thing is getting complicated. I guess I shouldn't write on a subject I don't understand. I looked up *community* in Wikipedia, and it mentioned something about *Gemeinschaft*: people bound by a common family, belief, or ethnicity. In contrast, *Gesellschaft* is classified more as a group bound by self-interest, like an association. Well, in this case the block party was a bit of both: mostly self-motivated African Americans participating in a celebration of their common bonds within the community. I know, I've ended up exactly where I started, but there is no better way to describe my confusion about this project.

As vague as my understanding of the concert was, I knew that Versailles, the mall, and the water towers were just my background: There was nothing to bond me with my neighbors. The shag carpets, the spherical speakers designed by my father, consumerism, and easy-listening TV shows had all succeeded in swallowing any need for a community. It seemed that community was replaced with comfort. I don't think I would want to see a concert about Versailles. Everybody would have to wear a big white wig to create a sense of identity. White wig versus White Castle? Sorry, that was terrible. My Tourette's just struck again. Did you know that many jazz drummers have Tourette's syndrome? There is even a community of jazz drummers with Tourette's who gather every year to play together. That must sound like hip-hop. I am an amateur drummer, and my Tourette's is mild: just bad jokes.

To finish with the Dave Chappelle concert: The only way I could understand the meaning of the block party was from my own frame of reference. I only had my background, and Dave's peers were part of a community. Not a community compared with another community, but a community compared with an absence of

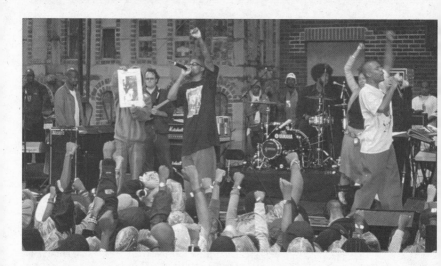

community. That's a very basic statement, but a valid and useful one to keep in mind when exposed to differences. This became apparent once when I was hanging out with Dave and his friends at a comedy festival in the mountains. It's a simple example, so don't think that I'm making generalizations. It's just about Dave and his group of friends, which I guess can count as a community. My son, Paul, who was fourteen at the time, had come along with me and really bonded with the crew. The night of Dave's performance at the festival, Dave and his friends promised Paul that they would go snowboarding with him the next morning. Paul was very excited with this prospect but didn't realize that they would be up all night. I told him, "Paul, I guarantee you they won't get up until the afternoon, so you better go snowboarding with the other guys or on your own." That night, the crew and I were hanging and hanging and hanging. Nothing was happening, at least that I could sense.

Selfishly thinking of my son, I asked Cory, Dave's music supervisor, "Why can't you guys go to sleep now, so that you can wake up at a normal hour tomorrow?" He responded, "You don't stop the vibe, Michel. You don't stop the vibe. That's why."

Damn it, what is "the vibe"? A collective mood? Intellectual exchange? Laughter? My excellent friend and director of photography Jean-Louis Bompoint plays the vibes, but he learned it from Lionel Hampton. It's not the same, and I know I am not even funny anymore. The answer came to me on a different occasion in Dave's hometown with the same people, in addition to Mos Def and Dave's mother. I had just screened *The Science of Sleep* for them, and we were having dinner. Long after dessert, we were hanging and hanging and hanging at the table (I just restrained a small Tourette's stroke with the word *hanging*). Not much was said. I was trying to feel the vibe. I had all my technological equipment ready to detect any type of vibration that my five senses might miss. Nothing. Two hours later, like the Big Bang, it came from nothing, out of nowhere: an idea. An idea to do a comedy tour in jails all over the United States. Everyone began throwing concepts and ideas onto the table to enrich the project: "Laughter is close to sex, which is dramatically lacking in an incarceration environment"; "We have our core audience, right there…" I even dared a joke: "The hecklers would be set free" (in stand-up clubs, hecklers are escorted outside by security people). Once more, it took Dave repeating my sentence to get any laughs. That night I understood what Cory had meant by "the vibe," and why I have never managed to make a hip-hop video: I was never there at the right time. Maybe the vibe is this invisible and secret way people from a community communicate, while the language itself is mostly used to confuse the outsider. If so, then my brother and I would belong to the Mumblers, a dangerous Versailles gang that assaults its rivals with obscure and incomprehensible concepts.

I guess knowing that I had not experienced the feeling of belonging to a group outside of my family made me tolerant—the main quality required to shoot a documentary. The advantages of this perspective became clear as I started to interview Dave and all his friends. I became acutely aware of what could transpire from being part of a community. As for my fear and complex about cultural inadequacy, I can proudly say that I passed the test. African Americans, including those who were part of the Brooklyn community, loved the film. Once I was even invited to an all-black fraternity at MIT to talk about it. They had all assumed I was black. To top it all off, I met Spike Lee once, and he let me know how happy he was that I had taken on the project. I think that by being careful I avoided the dangers of simplifications, obvious shortcuts, and manipulative imagery associations that can make a documentary dishonest.

3 | Shooting *Be Kind Rewind*

By doing *Dave Chappelle's Block Party*, I overcame one of my main fears: taking on a subject I wasn't part of and shooting without the skeleton of a story. That was exciting, and I wanted more. Also, I had experienced glimpses of Dave's magic at random times, and I wanted to continue experiencing it. While editing *Block Party*, I started to write a new screenplay, *Be Kind Rewind*.

I had Dave in mind for one of the two main characters, but trying to persuade him to be part of my movie reminds me of trying to get a girlfriend not to dump me: lots of hope and delusions. The thing with Dave is that he made it OK for me to talk about real people and the problems associated with differences in ethnicities, etc. I felt legitimate. And my utopia was once again tickling my brain. Utopian Tourette's: That is my precise condition—utopias burst out of my imagination without warning. A few years ago, I bought the boxed set of the *Planet of the Apes* movies, and watching these helped solidify the sustentation triangle that served as the basis for *Be Kind Rewind*. See, at the time they were shot, each sequel was cheaper to shoot than the one before, contrary to the current paradigm. So, by *Planet* number three or four, the budget would have shrunk like a mother's knit sweater in a washing machine at 160 degrees. So I thought, why not push this logic to the extreme and shoot remakes of famous movies for just one dollar?

That's how the sweeding idea began. After *Be Kind Rewind* came out, I found out about those kids who remade *Raiders of the Lost Ark* in Super 8, and I knew I would be accused of moral dishonesty, plagiarism, and all sorts of unpleasant things. Even

worse, I was later accused of ripping off a Nickelodeon show I had never seen. See, when you are a director and you put something out into the world, your ego is eaten with every sauce (that's a French expression): Some people will speak volumes of praise, while others will write mean stuff. I just canceled my Google Alert today.

So that was the triangle: community, self-made entertainment, and cheap remakes. And Dave Chappelle. So I guess that's a square. Only, like my girlfriends, he abandoned me, but that was not as painful, thank God. So back to the triangle. I was left on my own, about to direct a movie with many racial jokes, and the Spikes' spike again was poking my spine.

But I don't mind being scared when I shoot. In fact, it's a perfectly natural state of mind for me while working. So I went out on my own. I mean with a lot of people, but not Dave, and I shot *Be Kind Rewind* in the city of Passaic, New Jersey. As the writer-director, I discovered something extremely convenient: I could create a world that could fit my utopia. Of course, then it was not a utopia anymore, but a functioning system. Sure, this world was not a true reality, but still it was there and it let my system exist and be successful.

I believe in systems. Well, not the big and vague entity that seems to run the world against everyone. The system to which I am referring is more like an ensemble of imagined rules that allow a participant to achieve a certain outcome. The rules let people focus on a single moment, while simultaneously ensuring that all the efforts produced add up to the desired result. I found the same exact principal in a book on mathematical language: "One has just to adopt a procedure that possesses inner characteristics once for all established, and each time one applies it, one doesn't have to bother themselves: the procedure moves forward on its own" (*Why the World Is Mathematical*, John D. Barrow).

I create new systems for most of my videos. For shooting a video entirely with Lego blocks for the White Stripes without the use of CGI, I had to come up with a completely new form of organization with the team of animators. I create these systems so that regardless of the success or failure of the finished product, I know that I have at least tried to create something new. If someone invents a system that works, they often encounter strong resistance from most people because people assume that if the system is really all that great then it must already exist. It's really too bad. On this topic, my good friend and producer Steve Golin mentioned on one of the bonus tracks of the *Eternal Sunshine of the Spotless Mind* DVD, "Michel just doesn't like convention. They have been making movies for over a hundred years, and a lot of the ways they do things is because they work.... You don't realize how smart those ways are until you try to do it another way and you realize those things are done for a reason." I couldn't disagree more, Steve. There are a million reasons why people don't try new systems: They like safety; admitting the new system is better would mean admitting they have been using an obsolete one; some might find themselves unemployed with the new system; a system must be created by aged and obscure and intelligent entities, not by the guy

next to you; they are jealous because they didn't think of it; people are lazy; they think they will waste their time because ultimately they will have to redo the work using the proper method; nostalgia; they feel like guinea pigs.

And furthermore.

Once, my mom had an addiction problem with an over-the-counter drug. Something with codeine, I think. She could get it at any pharmacy, and they are all over the place in Paris. Nothing could stop her, even to the point where her life was endangered. So I Xeroxed her picture and went to the main pharmacy next to her place. "This is my mother, you can't sell her any more of the codeine stuff," I demanded. "I am sorry, it is an over-the-counter medication. It's illegal for me to refuse to sell it to her," the lady answered. Visibly upset, I said, "Then she will die, and you will be personally responsible for that." As I began to leave, the pharmacist stopped me and said, "OK. I know who your mother is and I will not sell her any more of this drug." It worked. Even better: Now engaged with my mother's difficulties, the pharmacist took the system even further. Mom was prescribed a monthly supply of sleeping pills but would consume the whole box the first week. So now, instead of giving my mother her entire prescription at once, the pharmacist gave her one pill a day in an envelope and two for the weekend. We had created a system that worked, and my mother was safe, at least for a while. It was, however, just a building block, one that would need much more work to create something that could last. But nevertheless, it was an unexpected and successful foundation.

During the filming of *Be Kind Rewind*, my systems compulsion did not exist only in the story—it began to sneak into the very way I executed the production. I wanted to involve as many people living in Passaic as possible. Passaic is a very ethnically diverse community: 62.5 percent Hispanic and Latino and 13.8 percent African American, according to the Passaic County Planning Board. There are residents from virtually every Central American and Caribbean country and a thriving Polish community. I didn't want the production to simply be an intrusion into those people's lives. I wanted them to participate in the experience and bring their individual personalities to the story. Moreover, I had even hoped to premiere the movie in Passaic, so they could see and resonate with themselves onscreen, like in my Louxor dream. (Unfortunately, we had to premiere the film in Clifton, the next town over, because Passaic had no theater.) I had seen this phenomenon while premiering *Dave Chappelle's Block Party* in his hometown. The excitement and pride were reflected in the eyes of the Ohio marching band that made the trip to Brooklyn.

The problem was that each sector of a film crew belongs to a union that did not exactly "appreciate" this inclusion. My union, the Director's Guild, provides me with excellent health care but forbids me from shooting under a certain budget. Similarly, the Screen Actors Guild forbids productions from hiring any non-SAG actors, unless there are at least fifty union actors already hired. But yet again, my utopian Tourette's came up with systems to avoid this. For the reenactments of Fats Waller's life, we needed small dance

numbers. I didn't want to have a choreographer or professional dancers because it had to be amateurish and fresh—qualities often forgotten with professionals. So we went around the main street of Passaic and got sixty kids to join our "improvised dance club." SAG could stop us from hiring nonunion actors, but they couldn't stop us from hiring dancers.

Twice a week, we would gather our new dancers in an old ballroom. One would think that the combination of sixty kids from the projects, an old ballroom, and choreography instruction would be chaos. Thankfully, this could not have been further from the truth. I did a quick interview with each kid (or adult) to make a rough selection. I asked them each to describe their favorite relative (I generally prefer when people don't talk about themselves) and do a little improvised dance number. We chose most of the people that auditioned. I remember not hiring the only professional dancer. She was already polluting the others with her preconceived ideas of what dance should look like: precise, affected.

Back to our ballroom. I randomly divided the ensemble into seven groups of eight people. I let the groups form naturally, allowing friends to be together if they felt better that way. After all, even I don't want to be separated from my friends at weddings. In each group, I spotted the one who could count a bar (1-2-3-4) of music. This person would be the leader of each group. I didn't do this so the leader could boss around the others. But rather, it was a way to ensure that the group would receive the best instruction from a peer. No real hierarchy was established, just like the guy who drives the car for his friends, nothing more. After we had established groups, we all watched some dance footage on a TV and talked about simple movements. The leader would then make sure his group learned it. I swear, in half an hour I had the sixty kids working quietly in the same room. No chaos. When people are given a chance to achieve something fun, they don't need the hassle of authority to stay focused. They always rise to the occasion, which is the easiest way to get the best of people: no management required.

In a couple of weeks, we created all the numbers we needed for the story. We were ready to shoot them just as we started production. The kids performed with a graceful clumsiness and tons of enthusiasm, especially when Mos Def or Jack Black was around. There were giant trumpet players formed by small kids on the shoulder of big guys who were dressed as giant pairs of pants, horn players bursting out of giant trumpets, which were in turn held up by other trumpet players emerging from bigger horns, etc. We had kids with musical notes attached to their heads walking up and down a music sheet coming out of Fats's piano. It was just a terrific spectacle.

4 | Rent Parties

Because it influenced my utopia, I must mention why I chose Fats Waller to be a role model for the characters of *Be Kind Rewind*. Of course, Fats Waller was not born in Passaic, but in New York, and participated in the Harlem Renaissance of the 1920s and '30s, during which rent parties played a predominant role. Harlem rents were exorbitant, and paradoxically, African-American families were confined there because whites refused to pay the unfair prices. In the late 1920s, a typical white working-class family in New York paid $6.67 per month, per room, while a black family paid $9.50 for the same space (*Harlem: The Making of a Ghetto: Negro New York: 1890–1930*, Gilbert Osofsky, 1963). So a solidarity system was created to help the inhabitants pay the rent. A piano would be brought into an apartment, and jazz musicians would compete and entertain partygoers on Saturday nights, charging anywhere from ten cents to one dollar, plus drinks. The money collected would cover the rent and pay the musicians. Pianists such as James P. Johnson, Willy "the Lion" Smith, and Fats Waller developed their amazing skills and pushed jazz music to the forefront of pop culture through these rent parties. Competition over the piano was fierce. Duke Ellington remembered the vibe and wrote about the pianist Art Tatum, "I knew that once in New York, he would be drawn into the Gladiator Scene with some real bad cats. I could just see the Lion, cigar at the corner of his mouth, standing over him while he played, and on the verge of saying 'Get up! I'll show you how it's supposed to go'" (*Music Is My Mistress*).

Once more, a community reacted to oppression by creating an

art form and a culture, and that's the element that Fats represents in the story.

Of course, the kids didn't just dance—they acted as well. Putting them in front of the camera among the professional actors created a level of uncertainty that kept the other actors on their toes. This combination created what I consider to be the perfect environment for the type of spontaneous acting that I like.

But the magic really showed up near the end of the shooting when my editor, Jeff, finished editing the whole Fats Waller story before we had wrapped production. It was about fifteen minutes. For the last scene of the movie, I wanted everyone involved with *Be Kind Rewind*, including the dancers, to watch the film they had shot. We filmed them watching it for the first time and used this footage for the ending. I wanted to see them get taken in by the images; capturing their first unfiltered expression before the knee-jerk reaction to act kicked in.

I think that they didn't expect much from those scenes, considering how rushed they were, and perhaps had forgotten about them by the end of principal photography. So I got exactly what I was hoping for: an expression of genuine surprise, pride, and laughter, loads of laughter. They would look at one another, as if to say, "That's my part" and "Look, there you are." Watching the sincere expressions of joy on their faces, I rediscovered what it was like to watch Super 8 home movies. As kids, my brothers and I would purposely wait some years before allowing ourselves to watch our home movies again. I remember studying each scratch on the image as a mark of a previous viewing. In fact, I would remember the last screening event rather than the actual moment captured on the film. That's the problem with photography: It records and erases at the same time. But again, I am stepping out of the subject.

After this experience, I began to think that my utopia was not so utopian. People really enjoyed the film because they were in it, just as I had expected in my initial Louxor idea. The group received direct gratification for their efforts. It did not come from compliments or flattery, but rather from the experience of witnessing their own creation. And this wasn't the same as just a single creator admiring his work; it was a communal effort and a communal admiration. It was as if each participant's feelings had floated into those of the others, creating something larger. And the key to my system was this: The people who shot the film were the ones who watched it. There was no concentration of power, so each person has the same amount of connection with the film. No hype. No coercive advertising. And no room for idolization.

This was the first time they had seen the film, and they had been given no directions on how to act when they saw it, so I assumed that it was an absolutely sincere reaction. I was now hoping it could exist in the real world, allowing my utopia to be a functioning system. One that could be reproduced everywhere, allowing for everyone to enjoy the gratification of being a part of a creative process.

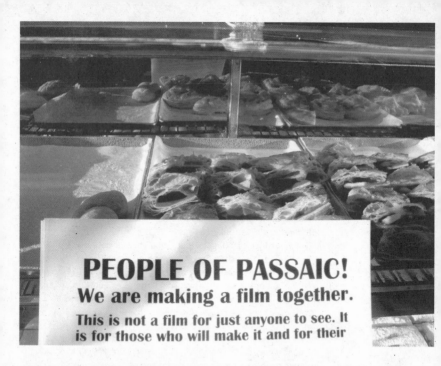

PEOPLE OF PASSAIC!
We are making a film together.

This is not a film for just anyone to see. It is for those who will make it and for their

5 | A First Failed Attempt

So, next I had to prove that my system would work in the real world. With Raffi Adlan, my friend and collaborator, I picked Passaic as our testing ground. We were given a location by the mayor, who had been very pleased with the shooting of *Be Kind Rewind*. We printed a couple hundred flyers at Kinko's and went through the embarrassing process of getting people to come to our first meeting.

The first protocol I imagined required four sessions of ninety minutes each. The first meeting would lead the group through the selection of the genre, title, and short storyline of the movie. During the second meeting, the group would refine the story and systematically turn each sentence into a scene. That was the system: If you have a story that makes sense when you read it and you take each sentence separately to transform it into a scene, you'll be able to tell the story with the camera, which is roughly what a movie is about.

The only problem is that there never was a second meeting. Even though we had twenty-nine people present at the first meeting who seemed happy and engaged (they even ate all the snacks we had brought), nine lost interest when they realized that this was not a real movie, seven were discouraged by the bad weather, and another eight we never heard from again. So in the end we were left with only five survivors who showed interest in actually doing the project.

The whole experience made me depressed, so I canceled the Passaic project. The five willing people, including Mr. Kenny Page, a street-sweeper-truck driver, were still complaining long after I let them down. But I was wrong thinking that the set of *Be Kind Rewind* was the reality of the world. This world that had been created, and the kids and cast watching their film, was not a reality, but an in-between. I had ignored the influence of the other actors, like Jack Black, who had added a bit of artificial magic to the experience, not to mention a solid reason to consistently attend the shoot. And of course there was the promise of being projected on the big screen. My system seemed to work only because it was held together by the big attractive filmmaking machine. Despite my best attempts, my utopia was still a utopia.

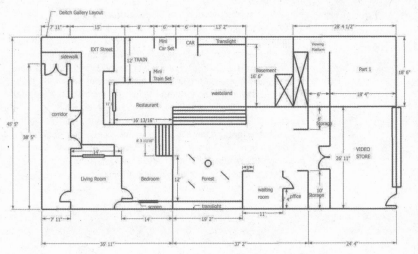

6 | Deitch Projects

But I couldn't just shelve the project in a corner of my mind for another twenty years. I had bragged about it to my friend Lauri. Lauri had a antiques store in the East Village and makes beautiful twisted animals out of fabric. One day, I animated one of those animals, and it was the beginning of a chaotic succession of dramas that you can experience in *The Science of Sleep*. Over the years, we managed to make our nonrelationship bearable, but she will

always be an artistic compass for me. She seemed impressed by my protocol concept, so I couldn't disappoint her. I know it's not very mature to undertake a difficult task only for the sake of getting approval from someone you care for, but I can't help it. Anyhow, I have made a living out of this condition. I had to find a way. It was at this point that Jeffrey Deitch reminded me that we had planned to do an exhibition relating to *Be Kind Rewind* similar to the one we had presented two years before for *The Science of Sleep*.

I had initially thought of a complex installation involving fifty computerized ropes that would form complicated and constantly moving patterns. It was an idea that had originally popped into my head when I was asked to art-direct an opera in Germany, but since it never came to fruition, I was hoping that maybe it could come to be at Deitch Projects. This condition is called self-recycling, and it's a common affliction in creativity. When you have an idea that you really want to see in the real world, you will do anything— even make a few creative sacrifices—in order for it to exist.

The same was true for my idea of the Neighborhood Movie Club, I was willing to do anything to see it come to light. So I had two options at Deitch Projects: the rope installation and the movie club. In order to weigh the two, I had to ignore the fact that I was supposed to make an actual physical exhibition. So I asked another inspirational friend, Gabrielle, which one she preferred: the mechanical rope installation or the filmmaking utopia. Gabrielle fills up little squares with people to tell stories. When they speak, there are balloons, but she always includes the feet in the squares. Without hesitation, she said, "The one where you make your own film." That was enough to convince me. My personality is soft Plasticine that is constantly molded by the fingers of pretty girls. In trying to impress them, I transform myself into a shapeless soft magma, which is anything but impressive. This pathology was exemplified in my collection of creepy little gifts displayed at the *Science of Sleep* exhibition. Jeffrey was also very much in favor of the film factory. Although he is not a pretty girl, his expertise was of great importance to me.

In my initial system, the gathering place was only used for workshopping, prepping the shoot, and screening. The neighborhood and its surroundings would serve as the set. This is still the idea at its purest because it requires hardly any setup, allowing it to take place anywhere in the world. But since I was adapting the concept for a gallery, I ultimately decided that it was best to build sixteen different sets as part of the exhibition. Although this wasn't the original idea, the failure in Passaic made me more open to change. This time, the whole protocol would take place in one space; all the brainstorming, planning, and filming would be completed in a two-hour session. The time limit would leave no room for discouragement or delinquency.

I kept the idea of splitting the exercise into two different workshops to reflect my initial concept of the two meetings. I thought that moving from Workshop One to Workshop Two would provide a sort of reward and stimulate the focus. No boring meetings, no flyers, no snacks; just one giant "film"-making machine.

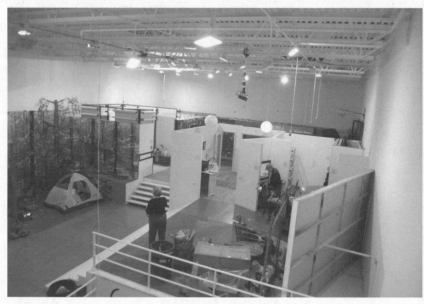

All the shooting would take place in the gallery, so we created a wide variety of interactive sets to ensure a diversity of stories. I had remembered the Universal Studios back lot in Burbank where *Back to the Future* was shot, as well as a million other movies. Many times, when my son was visiting me in Los Angeles, we would take the Universal Studios tour bus to visit the *Psycho* hotel, the *Spartacus* landmarks, the flooding river, the big plastic shark that would eat the dummy fisherman and pour red paint into the small pond, the real King Kong, the earthquake in the subway, and the lava tunnel. We loved the ride, never got tired of it. Especially when the bus would pass near the giant black telephone I had used for my Foo Fighters video. Once while riding the bus, we even happened to see Karen, my girlfriend, when she was working at Universal costume storage on the bus circuit. Life was beautiful.

I had actually planned to use every single set of the back lot for my proposed first movie, *The Green Hornet*, which never got made. You can see how eager I was at first to embrace the Hollywood system. Hollywood, it seems, did not want to embrace me back. But too bad for the burp bank, here I was in New York about to create a back lot of my own. I quickly made a list of all sorts of sets, both interiors and exteriors, that could support the maximum variety of stories. I generally don't think too long on matters such as these. It's pointless because it will never be perfect and I think spontaneity is an important asset in decision-making. After completing my list, I crossed out the sets that seemed unrealistic to build.

Of course I knew that the selection of sets I had made would have a serious impact on the outcome of the films. The two sets that had the most influence on the stories were the junkyard and the doctor's office. The junkyard induced episodes of drug dealers (*Re-Birth of the Game*), prophetic homeless (*Wombstone*), and homeless werewolves (*Night of the Erotic Moon*). Similarly, the doctor's office led to stories of humans birthing ducks (*Dirty Pretty Duckies*), a nurse's search for the cure to the Zombie Children virus (*Blood on the Floor*) and life-changing proctology experiences (*Eliot's Midlife Crisis or How to Kill a Man in 10 Days*).

Most of the other sets were neutral backgrounds for the stories, although I can tell that numerous ideas came from these sets as well, such as the café in *It All Started in a Café*, the forest in *The Mystical Sasquatch of Doom*, the car in *People with Cars in Houses*, and the bedroom in *Mushroom Head*. I organized the sets in a spatially efficient way, making use of multiple sets by connecting them through windows and doors. From the living room, you could see the street. From the street, you saw the interior of the café. Everything was designed in order to allow at least the semblance of continuity in the films.

Finally, we reconstructed the video store from *Be Kind Rewind*. After the groups completed their films, they would design their own VHS boxes, which would be displayed on the video racks. In the corner of the store, we had a screening area with fifteen chairs and a large TV. Once the group had finished shooting, they would watch it together there. The video store was the start and finish of the project.

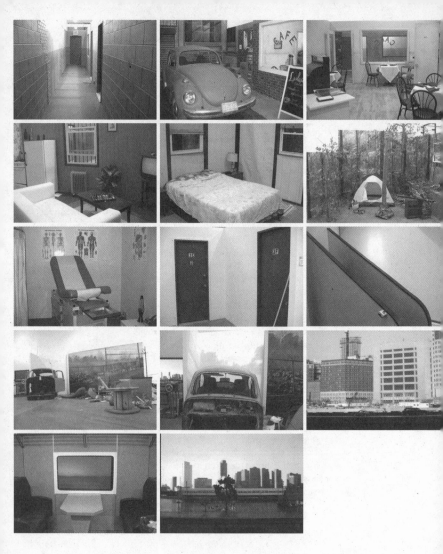

THE FINAL LIST CONSISTED OF:

- ▶ Long corridor.
- ▶ Exterior street with parked car and café.
- ▶ Interior café/mini-store.
- ▶ Interior living room/kitchen with view of street.
- ▶ Interior bedroom with video image projected in the window. Four options: forest/city; day/night.
- ▶ Exterior forest with fake camp and optional tent.
- ▶ Interior doctor's/gynecologist's office that could be transformed into police station (though no one made the transformation).
- ▶ Building staircase and apartment's doors.
- ▶ Static escalator with video projection of a mall moving up or down.
- ▶ Wasteland with cardboard house and some trash.
- ▶ Interior of the parked car. The gas pedal would change the speed of a video projection of a street with four options: city/countryside; day/night.
- ▶ Exterior of the same car: a mini-car placed on a spinning belt with passing cars connected to a video screen of a landscape that would move at the same speed, with the same four options: city/countryside; day/night.
- ▶ Interior of a moving train with a video image projected through the window. Four options: city/countryside; day/night.
- ▶ Exterior of the moving train: same principal as the mini-car.

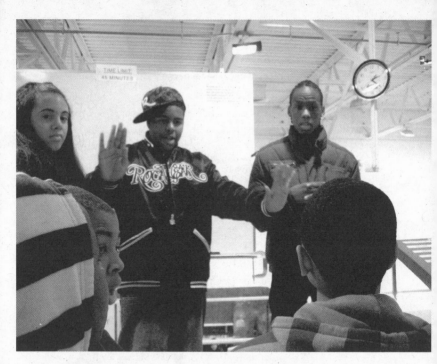

7 | Rebirth of a Utopia

In order to accommodate the various filming groups and avoid too much chaos, we set up a schedule so that groups could book ahead of time. Twenty-four hours after the official opening of the space, we had received over a hundred e-mail RSVPs. Within the first week, all our time slots were essentially booked. The problem was that most of the people who had gotten slots were the ones who had been at the opening event and were probably involved in the New York film or art scene. I don't have anything against those people (I am one of them), but my intention for this project was to open the experience to any type of person.

For instance, the first group that came to shoot a film in the gallery walked in with their own HVX camera, tripod, boom microphone, and lighting equipment. This seemed to go against the whole purpose of my idea. I was more eager to see the creations of people who didn't normally have artistic ambition. Or who don't have the privilege to to be professional "artists." One way to achieve this was to wipe out any sense of competition or any artistic pretension at the beginning and focus on the activity aspect of the concept. Sure, the environment of the art gallery was in sharp contradiction with this idea. I was aware of it, but the shelter and enthusiasm of Jeffrey Deitch were overwhelmingly engaging. I simply don't think I would have started the whole thing without that environment. Later I would have to pay the price when I read some of the reviews that stated that I was claiming those films as my personal creation. Well, I have to live with that.

The underlying assumption behind this protocol is that anyone's

idea is worth being expressed. The ideas or expressions we usually encounter in the public sphere come from people who are making a living off of them. We have very little access to those ideas that emerge from something other than financial or professional ambition. My French teacher in tenth grade told us before we started to write our first essay, "Your personal experiences are of great interest. All of your adventures are as precious to me as anyone's, except maybe those who have traveled a lot." Even though I disagreed with the second part, overall I found her statement liberating.

I also have a hunch that those who are lucky enough to express their voices to the world, the "professional artists," are not encouraging the "ordinary" people to be creative. Maybe because it is not in their financial interest to bring more people into their profession (the industry recruits through its own social circles). Recently, someone from a creative field approached me and said, "It's amazing, I saw my best friend from school the other day, and he told me he had just worked with you. It's such a small world." "Yes, it's a small world because we don't share it," I answered. OK, now I am quoting myself. How much worse can I get? Please forgive me. Still, despite its corniness, my statement accurately summarizes the situation. I believe that those, like myself, who have the privilege to make a living with their hobby rely on the rest of the world to buy our product to occupy themselves in their spare time instead of making their own entertainment.

Another discouraging element of people's creative power comes from the link between creativity and childhood. Part of the process of maturing is giving up on building the funny stuff, drawing, imagining, and so on. Unless you are lucky enough to prove that your childish activities are financially worthwhile, these interests are regarded as signs of immaturity. Even in my own situation, where my creative pursuits have proved to be economically viable, I am regularity considered to have a child's brain or the maturity of a six-year-old.

So we had to work extra hard to reach out to people from various backgrounds. We contacted schools and community programs from all five boroughs of New York. Since all of the appointments got taken right after the opening, the gallery staff would open the space at special times during the weekends when the gallery was normally closed. We would have teachers or community-program leaders come in on their off-time, and we would schedule them a special time.

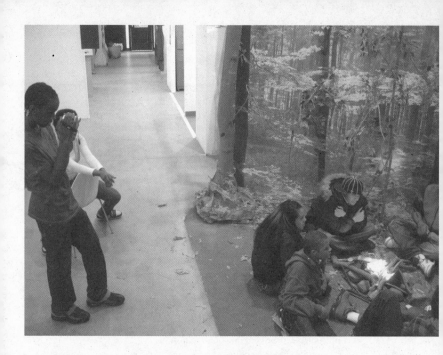

8 | Workshop One

On the day of their appointment, each group of five to fifteen friends would arrive fifteen minutes in advance so they could check out all the sets before heading to the workshops. The gallery staff would greet them and give them an extremely brief introduction to explain that the whole exhibit was self-explanatory and therefore it was absolutely crucial to read the instructions. The participants would receive a clipboard with the following instructions:

THE "BE KIND REWIND FILM CLUB" AT DEITCH PROJECTS

Welcome to the *Be Kind Rewind* Film Club. This exhibition allows anyone to create their own little film—or whatever they want to call it—in two hours, by following a simple protocol and using a selection of small sets that simulate both interiors and exteriors and offer the possibility to shoot a wide range of narratives. The camera is provided by the exhibition and will be returned after the film is finished and watched.

Here are a few quick tips:

► Please make sure that one group member reads OUT LOUD all of the instructions on the wall, as they are all part of the artist's intention and are essential to your experience of the piece.

► Remember that all the sets are completely interactive and designed for versatility. Groups are encouraged to configure each set in accordance with their narrative. For example, the office can be arranged to look like a doctor's office, a police office, or just a generic office.

▶ Preconceived movie ideas are strictly not allowed. Be spontaneous.

▶ Respect the time limits.

▶ Remember that imperfection is your ally. The mini-films are meant to be "spontaneous."

▶ Everyone (including those who are "shy") is urged to talk.

The group would then proceed to Workshop One, where one of the group members would read aloud the following text:

WELCOME TO WORKSHOP ONE
Your group will assemble at this station and have 45 minutes to decide on a collective strategy.

▶ You have the following production resources at your disposal: a prop photo board, set list, accessories/costumes list, and Switchboards A & B. You can also use the large whiteboard, paper, and pens.

▶ During this time, your group will confer and ultimately troubleshoot your ideas. You must follow the steps/directives located on Switchboard A. The buttons on Switchboard A are to be pushed when each task is completed.

▶ The group must collectively appoint a cameraperson, who will be in charge of leading the discussion, manipulating the switches, locating sets, and confirming completed tasks, as well as directing the camerawork during the shoot.

▶ At the end of the 45-minute period, your group should have established the following ideas: genre, title, and storyline.

▶ The various elements in your narrative will be decided by a democratic vote.

▶ The same process will be used for all decisions. When deciding on a genre, title, and story, the cameraperson will field suggestions from the group and write them on the board. When all of the group's suggestions have been proposed, the group will vote on each suggestion. Each group member may vote as many times as they like. *Note: A good idea would be to pick two titles, genres, etc. and combine them to create a more imaginative film.

▶ All group members are expected to contribute suggestions, and quiet members should be encouraged to talk.

▶ Upon completing Workshop One, your group will proceed to Workshop Two.

▶ Please proceed to Switchboard A to begin your tasks.

Time limit: 45 minutes.

At Switchboard A, the group would be presented with the following set of instructions:

SWITCHBOARD A
#1 Look at Sets of Switchboard B

Pressing each button on Switchboard B will illuminate a red lightbulb above the corresponding set to help you locate the various sets.

#2 Choose Cameraperson
As a group, vote on who should be the cameraperson. The cameraperson is responsible for the camera and leading the group during discussion and shooting. *Note: It is crucial that the cameraperson be vocal, assertive, and confident. However, they must never appear in front of the camera. After voting, everyone except the cameraperson should sit down. CHOOSE WISELY!

#3 Propose Genre
Propose various genres. The cameraperson will put each suggested genre on the board. When all of the suggestions have been written, choose one by voting. Remember that you can combine multiple genres. Each member can vote as many times as they would like. *Note: Although any genre is acceptable, groups are also encouraged to use personal experiences as inspiration for their narratives.

#4 Propose Title
Everyone is invited to propose a title. The cameraperson should write the titles on the board. The group should then vote on which title they prefer. It's OK if the group likes multiple titles; remember that you can combine titles as well.

#5 Choose Title
Once you have voted on a title as a group, the cameraperson must erase the board.

#6 Propose Various Storylines
The cameraperson should lead the group through a discussion to decide their storyline. All the ideas are put on the board. Vote on which ideas to keep. *Note: Your storyline must be between 8 and 12 sentences. Focus on creating the overall structure rather than specific actions and details.

#7 Choose Storyline
The group should take the various ideas they have chosen and turn them into a more coherent storyline. Workshop One should only be used for brainstorming and conceptualizing ideas. Please save discussion of specific details such as casting, story structure, and narrative sequence for Workshop Two.

#8 Write Your Storyline
Once your group has decided on a final storyline, the cameraperson should select an assistant to write it down on the paper provided. *Note: Your storyline should be concise and clear. Make sure that anyone could understand it. Your storyline should be written as though you were pitching your movie to a friend.

#9 Make Sure Your Storyline Is Complete
Ensure that your storyline is complete before moving on to Workshop Two. *Note: The storyline needs to be 8 to 12 sentences.

#10 Move on to Workshop Two

Video Box Gallery On the following pages is a selection of the video boxes created for the films made at Deitch Projects.

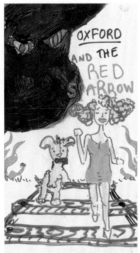

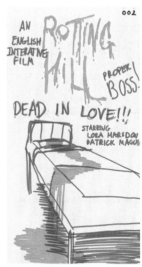

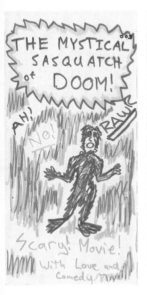

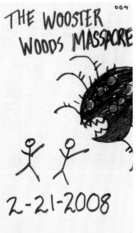

'PEOPLE'
IN CARS
WITH
HOUSES

★ ★ ★ ★ ★

ANOTHER
SOFIA
A TRUE STORY
OF
"WISDOM"

OUTSOURCING
DANGER

A Bollywood Lifetime
Original Movie

A FILM BY MARZIPAN

A.B.K

Alien Boyfriend
Killer

Not your typical high school crush...

TUFF KIDS
PRESENTS
RESIST
THE MUSICAL...

FEATURING
DOMINIC
CHERYL
CHANTAE
THOMAS (it)
MILKA
FABIEN
TRAVIS
GEORGIE
LOLA
DADA &
SENZ

RESIST the musical 2008

SASHA
MIK
JENNA
TIME
Rx MACHINE
ELI
LUCY
SARAH

THE WAY IT WAS
UN FILM ? NOIR
BY THE LAVA LAMP ? GANG !

WOMB SOLDIERS

THE BIG NAP
film noir for kidz !

GURLZ !
GIRRRRLS !
GIRLS?

BIGGER LEBOWSKI

"The dude abides..."

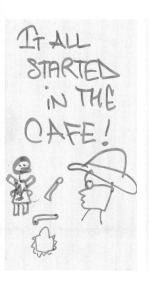

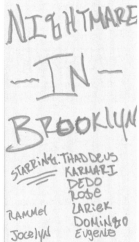

Global
Action
Project/
Washville
presents

Time
Limit

Le Croissant
Perdu

or

Batha is in the
IDLE TOWER

Watch it!

BLACK
CANDY

:5000:
++

A BLACK person
Scared STUPID w/
a Passion Always
Dies First

1st

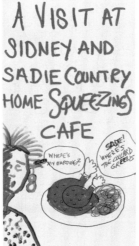

A VISIT AT
SIDNEY AND
SADIE COUNTRY
HOME SQUEEZINGS
CAFE

WHERE'S MY EARRING?

SADIE! WHERE'S THE COLLARD GREENS

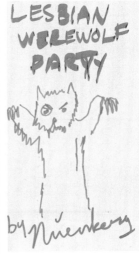

LESBIAN
WEREWOLF
PARTY

by Nuenkerg

Sweet Breads
D'Amour

First
Brain

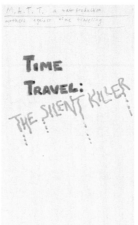

M.A.T.T. a matt production
mothers against time traveling

**TIME
TRAVEL:**
THE SILENT KILLER

PLANES, TRAINS
AND
CRYPTOZoology

The Patches
Bodacious Brothers
Frank Frappe Dong
Moment

Better
With
Lemons

Transit

EVERY1 DIES TWICE

BY: QUEENS ACADEMY'S BEST.

Running Gags

Asa Scott A.S...

007

In Death Trip

MOVIE: The Movie

Mushroom Head

BY: I.S.22, Students

THE Dream

The Dream

I.S. 229

2008
A MUSICAL QUEST Vol.1
THE SEARCH
FOR THE
LITTLEST
ALIEN
ROBOT
MONKEY

MONTY & TURTLE

Bad Super

A film by GASW
March 2008

THE
KATONA
BRIEF
THE EPIC STORY OF
DELEGATES 1-9

A CORO FILM

DONT
BE A
STRANGER

2 Girls, 1 Banana

MUSH!
MUSH!
MUSH!

42

TEETH THIEFZ

Gingivintus
of thee
Heart

GENERAL
HOSPITAL
#92

Kassandra
Jane Lesbians Ashayna
Dr. King
Nurse Nancy
Hazle Penalope
 Giggles

A Murder
? in the
Night
Featuring
James Bond
and
Nancy Drew
#85

MURDER on the Train

MULBERRY
MASACRE

CHOLI
con leche
EMERGENCIA !!
HMB

DARKNESS
CALLS;
Movie Night
Scream Night

Estephany Felipe
A. Reyna
Jessica J. nunca
"Crack man"
Chantelle
Shanaya
Andrew
Carlos K.
Andye S.
David McKay
Cristian Campos
Leslie
Angelica
Sue

Frankenstein
in the
Sun

WILLIAMSBURG
PREPATORY
HIGH SCHOOL

Time
Limit

The
SilenceR
of Music

45

TOO MANY CHILDREN IN A WHITE ROOM

THE Smartest MOB

REBIRTH OF THE GAME
(DRUGS DON'T PAY!..)
THE STORY OF BONE THE GHOST DRUG DEALER

"CLIENT #9: Sparkling Secrets: The Eliot Spitzer Story"

HELLA MUCHO

BABY MAMA DRAMA

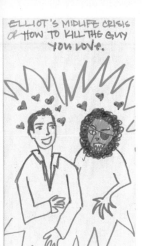

ELLIOT'S MIDLIFE CRISIS
or HOW TO KILL THE GUY
YOU LOVE.

The father of
cliché

Lost Kids ⚥

featuring: Luke, Eva, Eric, Tess, max
John, Fred, Jane, +Emma

Popping
Benadryl!
Restrictions may
Apply. ^◇^

Saperlipopette.

A french Zombie movie!
(also american Zombie movie)

Sapealipopette.!!

H Dance
on Your
GRAVE

Holiday Death Camp

Exclusive!

GERMAN for THEFT:

Someone Steals an ELEPHANT

by: people

120

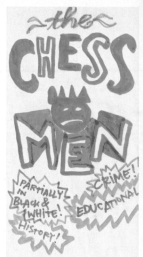

the CHESS MEN

PARTIALLY IN BLACK & WHITE!

CRIME!

EDUCATIONAL

HISTORY!

The first workshop was situated on the balcony overlooking all the sets. This workshop consisted of fifteen chairs, a whiteboard, a set list, a prop list, and two switchboards. Switchboard A had a list of ten directives with a lightbulb and button next to each instruction. When the group accomplished one of the tasks, they would push the button and the bulb would light up. Switchboard B had the list of sets with a button next to each, which, when pressed, would illuminate a red bulb above each corresponding set in the gallery. The buttons and lightbulbs were designed to be small, playful activities that encouraged people to follow the order of operations, so that they could achieve the end product. In this case, it was important that they look at the variety of sets, so that their narrative could work within the sixteen sets.

When I first began to structure the protocol for these workshops, I was aware that I had to establish rules and restrictions in order to ensure the widest range of creative possibilities within the given time. Of course, I know this is a contradiction, but I chose rules that would inflict the least amount of damage on a group's imagination. This balance between freedom and restriction was crucial for the system to function. For instance, it was necessary to bend the equality of the group by designating a cameraperson to be in charge and ensure that chaos did not result in precious time being wasted. I remembered when my son attempted to shoot little stories with his friends, they would often be more concerned with who was holding the camera than with starring in the film. I guess the technological aspect of the camera garners more respect than starring. By designating who was responsible for the camera, I also figured it would guarantee that the camera would not be stolen or carelessly damaged.

Creating a system is like programming software: You have to imagine all the possible loopholes. I remembered that in the Passaic dance club, I had used a simple technical skill (counting one bar: 1-2-3-4) to help select the natural leaders who would have a positive impact on the group. The apparent advantage of being selected as the leader would be counterbalanced by the weight of extra work and responsibility, so it could somehow be regarded as a sacrifice. That way, nobody felt undermined. To help equalize the balance of power between the cameraperson and the rest of the group, I restricted the cameraperson from appearing on camera. This also created a possible escape for the group member too shy to appear in front of the camera. This role would eventually give him or her an added concern for completion, allowing the rest of the group to be more imaginative and free-form in their stream of ideas.

The next task was the selection of a genre. Asking the group to define this at such an early stage might have overly restricted the possibilities for the rest of the process, but I think it was the easiest and most efficient way to help people break the ice and talk immediately. Here I go again with the minimum damage. Generally, two-thirds of the team knew one another and one-third were strangers added on at the last minute. As soon as the group started throwing out genres, it allowed complete strangers to start making connections over common interests. This simple task had

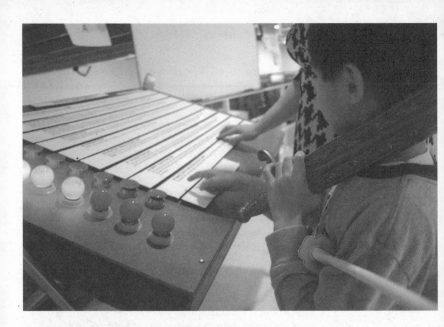

everybody instantaneously jumping in: "Oh, I love noir, too!" Occasionally, when a group didn't show up for their time, we would go around the gallery and pull together an entire group of strangers. These groups would almost always work more efficiently than groups of people who knew one another, because no one felt comfortable enough to argue or mock other people's ideas: It was just pure collaboration.

When I participated with some of my friends and the gallery staff, I realized the impact of the genre decision. I suggested documentary, which in the end was combined with horror and instructional. The documentary genre allowed us to cast at least half of the group as the film-within-the-film crew, which was helpful since we had a group of twenty-two people. For some of my crew, this decision even provided an outlet for revenge, as they were able to cast me as Disgruntled Intern #1. Tim Robbins was part of our group. He came by the exhibit one day to visit his son, who was participating with his school, so I invited him to come by later in the week when we were planning to do our own film. Tim even invited Susan Sarandon halfway through the experience when he realized how much fun we were having. We gave her a cameo.

As Workshop One progressed, sometimes the group would stray from their original genre decision, but they would refer back to this genre when they got stuck on the plot, usually when creating an ending. This created many intense endings, such as children killing all the adults of NYC or the world being turned into one giant zombie dance party.

After the genre was decided (or built from several), the title had to be picked. Our group's film was called *Eliot's Midlife Crisis or How to Kill a Man in 10 Days*, and it was a documentary horror picture. Looking for the title was where the good fun started. By this time, the group's confidence was on the rise and social inhibition had all but vanished. It was common to hear lots of laughter coming from a group of people who had known one another for ten minutes. The title and the genre(s) provided the perfect framework to let creativity burst out. Here is a sample of the discussion for the title of film #114:

> "OK, now it says, 'Propose title.'"
> "*How to Be a Wizard.*"
> "*How to Be a Wizard and Solve Crimes Involving Monsters...*"
> "*...Hosted by Humphrey Bogart.*"
> "How about, *Which Witch to Wack*?"
> "or *Which Wizard Was It That Wacked the Witch*?"
> [*General group agreement*]

Then, somewhere in Workshop Two, the person who made the narrative card wrote *Witch Witch Wacked the Witch* and the group just went with it. I have always found that limitations and perimeters are not restricting but in fact liberating. If you don't believe me, ask your friend who speaks a foreign language to say anything in his foreign tongue. Nothing ever comes out. Same if you're asked to test the sound of a microphone. Same result, "Test,

OXFORD AND THE RED SPARROW

test, one two, one two." I apologize for those lame examples, but they seem to suit my point. That is the exact reason why I started to build the pyramid from the top. Of course it seems absurd to select the genre first. But when this is done, it provides a ground to think of titles. Ask people to throw an imaginary film title out of the blue. The answers will be scarce. Do it again after the genre (horror) has been established and the ideas will zoom across the room. That is the basic idea behind the protocol. Once more I am not preten-ding to explain filmmaking. But once the title is found, it becomes immediate and fun to propose storyline ideas. As the group progressed, the tasks would require more complex ideas, and the top-down approach provided a more supportive framework as the tasks became more difficult and open-ended.

Certain unique title and genre combinations practically wrote the storyline for the group. For instance, what would be the plot of the horror noir *Black Candy 5000*, the documentary musical *Something's Coming: Don't Look West Side Story*, or the comedy thriller *The '86 Mets Find the Pirates and Win the Lotto*?

When choosing the storyline, the cameraperson would write the proposed ideas for the storyline on the board, while the others would check the sets and the props to find more ideas. So ideas would pile up exponentially. For example, for the spy thriller *Oxford and the Red Sparrow*, the conversation went something like this:

"OK, so our title is *Oxford and the Red Sparrow*, so I think *Oxford and the Red Sparrow* are two of the world's greatest spies."

[*Sounds of general group agreement*]

"Maybe it's just Oxford who is a spy, and he's looking for the Red Sparrow." [*Sounds of general group agreement*]

"The Red Sparrow should be a key... to turn him back into a dog, because he was turned into a dog by an evil doctor."

"No, it was the evil mutator who turned him into a dog."

[*Sound of laughter and applause*]

The round-of-hands vote had been suggested at the beginning to make sure democratic principle were respected, but as the group evolved, shortcuts were found in many ways. Generally, the agreement on decisions would become obvious naturally, as if laughter would count as a round of hands. It would still be useful in case of a disagreement, as a sort of group counseling.

9 | Teachers

We had needed the help of teachers to bring students to Deitch to participate in the shooting. This was also the best way to try for diversity. Unfortunately, once the teachers were there, it could be hard for them to adapt to the protocol, which lessens their authority a bit and pushes them to be simple participants. There is the case of Professor T., who was clearly using the exhibition as a way to lecture his students on film. He let one of the students be the cameraperson and lead the discussion, but as soon as there was any holdup, he would always run to the front of the board. Professor T. was ultimately the cameraperson. I noticed early on that he was very concerned to maintain a low level of voices and profusely hushed during all the sessions. As soon as excitement would emerge, he would break it and ponder: "This is how they do it in real life. It's what I've been trying to tell you guys in class," he would say. He clearly instilled some doubt in the kids' minds, as well as the idea that they should be concerned about professional standards, and he would question their story if it became ridiculous. In the workshops, he would lead the group and use each of the directives as a teaching moment. Eventually, he shot the group's entire film himself.

After this misfire, we told all the teachers that they should not intervene in the groups in any way. "Do you really know what you're doing?" asked the first teacher confronted by the new rule. Jordan responded affirmatively. Workshop One had already started. There was a pause, and one of his pupils said, "What's the next thing?" "I can't tell you anymore, because they won't let me lead you," the teacher answered. At that, there was this amazing look in each of the students' eyes, like they had just been told school was canceled forever. They all got up and started throwing out crazy ideas and finished faster than other group that came through. Their film was about a girl getting pregnant from some guy who had a lot of lovers. One of his lovers was upset he was sleeping with the pregnant girl, so she decided to get a group of friends together to kill the girl. There is a huge brawl, and the story ends with the violent girl getting arrested. The film uses incredibly course language, but there's something vividly authentic about it. The students were treating the heaviest subjects so lightly—they must have been drawing from the life around them.

I had a few conversations with teachers who admitted how hard it was for them to let go of their authority, even for an afternoon. As if it were a title they'd earned the hard way and were fearing they'd lose forever.

The thirty-eighth film, *Nightmare in Brooklyn*, was done by our first school group, the Gotham School for the Arts. Their teacher quickly understood the nature of the project and accordingly intervened only occasionally, mainly to remind his students of the time or explain certain terms they clearly did not understand, like genre. Consequently, the kids were definitely out of hand, but in a good way: They had huge arguments over who was going to die first or die at all (even though they chose horror, no one wanted to die). They also picked a quiet cameraperson, and the group worked with less structure, but they seemed to have a built-in defense against egocentricity. For instance, a member who was full of loud sugges-

The Grid

Storyline	Day/Night	Set/Location	Action	Character Names	Name of Group Member Playing Role	Accessories/ Costumes	Narrative Cards

tions left the group and sat in the corner because people were angry at him for talking too much. He was mad. He felt his ideas were not given a chance. The group had to kill him early in the plot. That is not very democratic, but it is funny.

This happened toward the end of the exhibit so only one group was able to experience this new rule.

The creative process, at least the way I see it, is all about expansion and then compression. The expansion allows the flow of ideas to be unrestricted within fixed parameters. The compression is the selection of the ideas that will ultimately turn it into a story. This is the phase when reality hits you, but that's not to say that it becomes less creative at this point—quite the contrary. It is like giving a haircut to the project. I am sorry, my Tourette's is not funny anymore. I must have reached the terminal stage. Anyway, at this stage of the workshop, sacrifices are made to preserve the best elements, the ones that help the whole project. We say good-bye to the ones that are inhibiting the project, and eventually combine some other ones to create even better ideas.

When the group got to this point in the workshop, time had become much more crucial, so quick decision-making was naturally encouraged, if not forced. But that's for the best. In my work, I always have to balance the time spent on the decision and the overall importance of the decision itself. I found that, very often, time is more precious than the right decision. The randomness of choice can often bring quality to a project. So it's all for the best.

Another silly example to help my point: At a restaurant, if the waiter asks me whether I prefer salad or soup, I usually say, "Salad" in my mumbling and obscure accent. If the waiter answers, "Soup," I almost never correct him because the energy I would spend to do so is more important than the difference about the food. Maybe I'm just lazy. I am not saying that every decision has to be butchered—it is important to make good decisions in general, but not always. Sometimes it doesn't matter.

So, anyhow, the crew would eventually nail an eight-to-twelve-sentence storyline and get the hell out of Workshop One.

WELCOME TO WORKSHOP TWO

▶ This workshop provides your group with a storyline grid. The grid should be used to write each scene and allocate roles. When completed, the grid should act as a detailed map for the group. It should contain all the information necessary to complete the shoot. All group members should now take a seat except the cameraperson and the grid writer.

▶ Once again, the cameraperson will discuss ideas with the group. In the interest of time, one group member must be in charge of writing on the grid, while another person must fill out the necessary narrative cards.

▶ You are asked to pay particular attention to the grid, as failure to fill it out accordingly will result in a bad time-management strategy. Please read the description of each element before you fill in the corresponding box.

▶ You are advised to engage as a group and assign the necessary group members roles, etc., in the space of 45 minutes. The following will be confirmed at this point: storyline, night/day setting, set/location, action, character name, role, accessories/costume, narrative card. *Note: A well-balanced grid is a well-directed movie.

▶ There is a photographic display of each set on the wall. It is useful to consult the set list when developing your narrative. Feel free to utilize the photo prop board, the set list, and the craft materials available to make any props that you might need.

▶ Each group will now proceed to the Camera Station to pick up a camera.

Time limit: 45 minutes

USING THE GRID

▶ Storyline: Each of the 8 to 12 sentences of your storyline from Workshop One should be individually placed into a column box. Each sentence should represent one scene. If a particularly long sentence requires more space, you may wish to divide it into multiple boxes. When you have completed filming, your movie should essentially consist of 8 to 12 scenes. Note: The grid must be filled out HORIZONTALLY. To save time, the group should designate someone to write on the grid while the cameraperson leads the discussion.

▶ Day/Night: Determine the time of day for the scene.

▶ Set/Location: Choose the set in which the scene will take place.

▶ Action: This box allows you to provide a more detailed description of the action and details within the scene. The scene MUST reflect the sentence that it is illustrating. Work as a team to creatively tell the story. Remember you only have 45 minutes!

▶ Character Names: Determine which characters will appear in

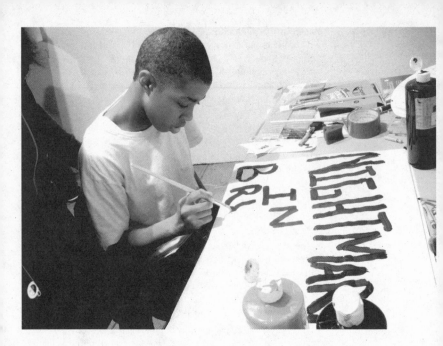

each scene. The group is encouraged to be imaginative when deciding on names.

► Name of Group Member Playing Role: The group must decide which members will play each role. Members cannot choose their own role; instead, they can only propose other people for roles. Any conflicts or overlapping roles can quickly be resolved by a vote. Avoid egocentricity and stubborn attitudes. Every member must have a role and appear on camera in at least one scene. If a member is not proposed for a role, they may create one for themselves and the story will be altered accordingly.

► Accessories/Costumes: Decide which costumes and props will be used to enhance the narrative. Consulting the set and prop list will help you decide how to dress each setting. Remember that the sets are specifically designed to accommodate a number of scenes; for example, the doctor's office can be transformed into a lawyer's office.

► Narrative Cards: These cards are used to create scene transitions. While the grid is being filled out, a group member should use the craft supplies to design each card. These cards are optional but may be useful to bridge scenes or provide context. The following can be used as a guideline: "The next day," "In a small town," or "Georgina lost her mind at this point." Remember that you can also use the location photos to introduce a scene.

► *NOTE: THE FIRST SHOT OF THE FILM MUST BE THE TITLE CARD.
► EACH FILM MUST ALSO INCLUDE CREDITS.

Moving from one workshop to the next provided some fresh energy for the group. At Workshop Two, the tasks became a bit more technical. But don't worry, there is still a lot of fun ahead. In fact, that was the most fun I had when I did it with my group. One could argue that this added fun just happened to coincide with the delivery of a few cases of beer. Yes, that might be true.

So the basic idea with this workshop is that the group would translate each sentence of the storyline into a scene. With each scene separated, they begin to plan the other various details of each scene: time of day, characters, casting, action, props, and setting. At this point, the storyline has started to take the most ridiculous and hilarious turns: love affairs with tree branches, time-travel journeys to drink Crystal Pepsi, a search for Matthew McConaughey's dog, and Frank Zappa sing-alongs were all thrown into the mix. No one in the group really wanted to upset another member by rejecting an idea, so there was a lot of comprising that ultimately compiled some absurd narratives. It's a mix between an exquisite corpse and Scrabble. Once more I apologize for my images. But it felt like that, I promise.

Naturally, the tasks of Workshop Two forced the group to start making practical decisions, like how they were going to shoot certain things, like an announcement coming from a radio, the point of view of a giant, and so on, and of course who was going to play each role. Casting is usually a process where ego comes into play. To make sure the more outgoing members didn't completely dominate the group, participants could only propose roles for other people and never for themselves. I discovered that this is a very efficient way to combat egocentrism. Of course, it didn't always work out so fairly. Even in our group, people would break the rules and propose themselves for the less prominent parts. Michael Hausman, my dear friend and renowned veteran producer, insisted on being the proctologist, and Raffi wanted to be a werewolf just because he had a beard. So we all agreed. At some point, the whole group conspired to put me up front as the lead man, and I had to use all my skills in human manipulation to get me out of that trap, settling for the easy Disgruntled Intern #1. I convinced a majority that Miguel Ian Raya, our office manager, was the perfect choice to play the hit man. And he was perfect. We found out later that some groups would have some real sneaky members who would secretly ask other members to propose them for a certain role. The rules are there to make the game more efficient, but they can be bent at any time.

On some occasions, though, I found that disregard for the rules was too damaging to the experience. Once a young guy, probably a potential director, came with a full storyboard of a film he wanted to shoot with his three friends. What he did not anticipate was the fact that there were two other strangers added to his group at the last minute. He bypassed most of the first protocol in Workshop One, explaining to the rest of the group that he was saving them from the burden of this work (thank God!). This young man was ruining the entire experience for the other members of his group. This was the first time we had encountered

this situation, so Jordan and I quickly discussed our course of action and we decided to interrupt his dictatorship and ask the group to start over, reminding them that preconceived ideas were not allowed. This shows how different this activity is from actual filmmaking; in film, you have to be a dictator to run a set. You can't let everyone step all over you with countless ideas. I mean, yes, you can listen to them, but you have to be able to say no to them. Otherwise the film has no voice. I know, I am contradicting the whole text I have just written, but I tell you this is not an exercise I practice every day of my life.

On this topic, there is this good story that every filmmaker knows: John Ford was directing *The Man Who Shot Liberty Valence* with John Wayne and other friends. They had all shared the cost of the film, as no producer wanted to invest in it. For the first time on the shoot, John Wayne, legitimized as a producer by his financial participation, suggested, "Why don't I play the scene this way, then run away like this with my horse?" "Very well, let's do it," the veteran said. So they shot it Wayne's way, and he went all the way to the horizon with his horse. When he came back, Ford opened the camera's mag, exposing the shot film to the sunlight, handed the roll to the actor, and said, "Here is your scene."

Well, I don't do that, but my point is that my system is purposely removed from real filmmaking. I don't want people to think I am pretending to teach how to become a filmmaker, especially the people who think I am incompetent in that domain anyway. Some of them can easily be recognized because their thumb is pointed down. No, this protocol is an activity, like an amusement park—a ride that doesn't belong to a big studio or a corporation, but the community. And here the group was the decision maker: That was the whole point of the idea. Everybody should have equal fun, and nobody should be left behind. Oh, I forgot to finish the story about the guy who wanted to direct his storyboard. He started over from scratch, to the relief of his team.

Another time, a group of filmmakers came in with a completely predesigned reproduction of *Blade Runner*. They didn't want to follow any of the tasks, but just to use the space as a free studio to shoot a video. After they were informed that preconceived ideas were not allowed and that they would be ruining the experience of the strangers in their group, they decided they didn't need to follow our system since they "did this for a living." They were asked to leave. No thanks.

In Workshop Two, there was a lot of hands-on work to compensate for the constraint of filling the whole grid. We had provided colored paper, Sharpies, paint, etc. Title cards had to be created. By the way, did you know that's how Hitchcock started in the film industry? He painted title cards. I am so know-ledgeable. And there is this other story, similar to the John Ford one. During the shooting of *The Birds*, Tippi Hedren asked the master: "Why is my character going to check the attic at this point?" "Because I asked you to," he answered. To this day, I don't understand why she goes to the attic. He should have tried to find a decent answer. I would have.

11 | Shooting

By the end of the forty-five-minute period of Workshop Two, it was rare that the grid was fully completed, but it didn't matter because the team had already tapped into the momentum and excitement of their story. With the whole plot imprinted in each cortex, they were more than ready to go into action. The group's energy was at its peak and they couldn't wait. In fact, even before the shooting, the action had already started; those who had exhausted their patience planning the story, like fidgety kids in a restaurant, found their stride in the more creative details such as prop finding/creating, narrative cards, or wardrobe. These roles were not imposed by the cameraperson but were instead self-selected. This absence of hierarchy turned out to be very efficient: People were led by their own motivation, not by the orders of a higher-up; excitement rather than obedience was the fuel. The time constraints seemed to strip away most egos, and there was no time for pride. For example, during our shoot I remember darting around all over the place: helping Raffi put in his werewolf teeth without swallowing them, stopping to watch Michael Hausman dress as a proctologist, and then going down to the basement to sing the suspenseful theme song along with Tony and Aaron while they were shooting the freshly painted opening credits.

By the end of Workshop Two, the group was completely self-structured: The cameraperson would now know how to respect the general opinion, thus bypassing the voting process; the handy ones had busied their hands; the motivating ones were already motivating; etc. The group ultimately created its own collective intuition in just a few hours.

Camera Checkout Station

▶ After your group has created a complete storyline, grid, and set of narrative cards, you can check out a camera at this station.

▶ A volunteer will brief you on the basic functions of the camera.

▶ All editing must be done in the camera.

▶ The order of shooting will be chronological, strictly dictated by the order and details on the grid from Workshop Two. Properly following the grid will ensure a successful shoot.

▶ You have ONE HOUR to complete this stage.

▶ The cameraperson should exercise caution when preparing to shoot a scene. He or she should hit the record button after yelling, "Action," otherwise the command will show up in the group's film.

▶ There are no retakes. One take, good take.

▶ Note: Don't forget, perfection is the enemy, it will lead to discouragement. Mistakes, repetitions, and stuttering will be all the more fun to watch at the end!

▶ The cameraperson will direct the action of each scene by reading the storyline sentence and description of each scene from the grid. The cameraperson can shoot the whole scene in one take or segment it with different angles. It is recommended that you try to respect the flow of the conversation and remember at what point in the dialogue you stopped recording, in order to successfully resume.

▶ WHEN THE GROUP IS DONE FILMING, TURN IN THE GRID, STORYLINE, AND NARRATIVE CARDS, AS WELL AS THE MINI-DV TAPE. AFTER YOU HAVE TURNED IN THESE ELEMENTS, YOU WILL RECEIVE A BLANK VHS BOX TO DECORATE.

Only the cameraperson could hold the camera and was required to personally return it to the Checkout Station stand. When checking out the camera, they received a brief tutorial and an explanation of the rules for shooting. The main rule for the camera was that all of the editing was done in the camera. This is another key feature of the protocol, and it bypasses the whole postproduction process. Basically, when the last shot is done, the film is ready to be screened. There is no messing about.

This "in camera" editing technique always reminds me of funny moments when my son, Paul, was shooting his horror movies with my little brother, Romain. They would spend so much time worrying whether the door was closed or open in the previous shot. During screening it was precious to hear his preadolescent voice whispering, "No, wait… now go. Yes, I am filming…"

Shooting with my friends at Deitch Projects, we too were gratified by those magic moments. Tony, the cameraperson, even though he was not allowed to be part of any scene, managed to have the best one-liner of the entire film. How? Well, we were preparing a scene where Miguel, his wife, and the whole documen-

tary crew, led by Tim Robbins, squeezed into the orange Beetle to continue their investigation on the way to the mysterious proctologist. We were about to shoot the exterior version of the car in front of a moving background, and we had to find a line for Miguel to say off camera to pretend the sound was coming from inside the car. We couldn't find anything interesting enough, and Tony, in his British way, just said, "I am a hit man, do you have a problem with that?" A hit line for a hit man. But how did it make it into the final film? Tony had forgotten to stop the recording of the previous shot and shot his feet for at least five minutes while we were rehearsing. The "antiground" function addressed this problem in early VHS cameras, when people were not well acquainted with the technology.

So, when it was our turn to watch our movie, we had an extra five minutes to endure. But Tony's delivery was well worth the waste of time. It turns out we were not the only ones who made this mistake, in fact it was the most common error in the entire process. I guess cameras stopped carrying the antiground function a little too early. In the future, we must reinforce the rec-pause-rec technique.

Another frequent problem was due to overzealous individuals whose professional aspirations ruined the experience for the rest of the group. Here comes our friend Professor T. again. As I mentioned before, he clearly had ambitions to become a filmmaker. So the rec-pause-rec technique didn't meet his professional standards. He had to rewind the tape after each take to check the "quality" of the performance. Disbelief and disappointment were on everyone's faces during their final screening when they discovered that a large portion of the story was missing: Their teacher had recorded over them by mistake.

In another instance, a professional director of photography asked millions of questions about the camera that our staff thankfully couldn't answer. Then instead of just shooting, she spent ten precious minutes (the shooting was limited to one hour) messing with all the settings. And after all that, she committed the deadly "ground shot" error. Better is the enemy of good. Later, the unfortunate director of photography came back and begged us to re-form her group and give her a chance to redeem herself. She said her mistake had ruined her relationship with her friends. We complied, but, once more, she failed. This reinforced my point that often, the most incompetent people could be found in the middle of their own field.

But overall, the shootings were a collection of delicious and hilarious moments. In *The Day the East Side Stood Still: Giants vs. Trolls*, after landing in their flying tent from outer space, the two young trolls (played by two young kids) make their way by train over the East River to scare all the adults of Manhattan with their troll swords. Their parents, playing the part of the giants, used the miniature train sets in the wrong way to create the illusion that they were huge giants. In the porno-horror-musical flick *Night of the Erotic Moon*, Kenny Page, the street-sweeping truck driver from Passaic, was assaulted by a hoard of forty-year-old women he had met just an hour before. And who could forget about all the boys, girls, and even grandmas giving birth to paper-cutout babies,

monsters, ducks, bombs, and weapons in the doctor's office? Never has there been a gynecologist who has witnessed so many odd births in his private practice. The most hilarious memory of our shooting was when Tim Robbins, suddenly engrossed in his film-maker role, let slip a "Wait a sec, you are crossing the line here." We all laughed at how obsolete his comment was in the general chaos of our shooting. Among the most memorable shootings, *Womb Soldiers* was by far the most visually interesting. It was done by a group of lesbians who brought in a carload of props and radically redesigned each of the sets with neon-colored cloth. We were in a meeting in the back (about this very book) when they arrived. Raffi had stepped out to take a call. When he came back in, he asked, "Is it OK that people are bringing their own props?" I said it was fine, but he responded, "Maybe you should take a look at this then, they've got a lot of stuff—like a live chicken." The other gallerygoers who peered into the back alleyway (originally intended to shoot police chases) saw a bunch of naked women with unshaven Venus mounds and a live chicken. Their male musician friends had set up a noise band to create a tribal hypnotic score.

They used the camera in a very unorthodox but creative way: They recorded twenty minutes of their naked bushy bodies wrapped in transparent plastic film, rubbing against the corridor, like preborn babies—sperm, eggs, who knows? Then they rewound the whole tape and recorded over it randomly, adding scenes of an acrobatic pregnant bride, two twin girls covered in pink paint and Visqueen tied together with a handmade umbilical cord, and colorful close-up shots from inside plastic neon-pink tubes. This was the closest thing to actual "art" that we encountered and it was totally good spirited and unpretentious. Congratulations. In fact, this film was by far the most requested film at the *Be Kind* video store... for educational purposes, I believe. Funny to mention that when he came back to Brooklyn to help me with this book, Jordan ended up living at their house... for educational purposes as well.

Of the 122 films shot, only a few were left incomplete. Most groups found ways to overcome obstacles in order to finish their film. For example, the main character of *Witch Witch Wacked the Witch* had to leave in the middle of the shoot for a dinner. The group wanted to finish so they agreed they would just kill him in the story, so the plot could resume without him. As the shooting progressed, the groups would become more excited by the reward (the viewing part), as they could hear the laughter from the previous group screening their creation. Like in a dentist's waiting room, except with laughter. No one abandoned the project because of technical difficulties. They always used creative and simple solutions to solve these problems, making their film more special in the process. In fact, the ingenuity grew more elaborate over the month, as if the groups were challenging one another. In *Dog Gone It*, which featured the news station Flox News, instead of using a digital news ticker, the group wrote small headlines on skinny pieces of paper and had someone sit underneath the camera and move them across the frame. A few films after that, a group took it one step further by doing its entire film with paper subtitles.

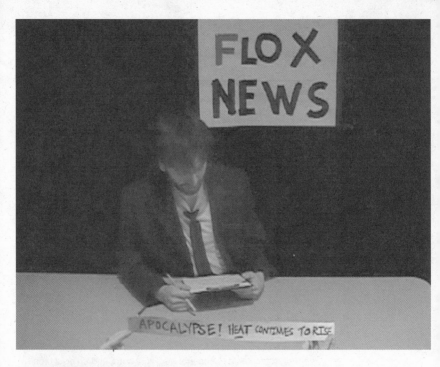

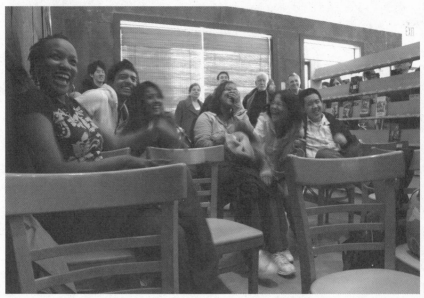

13 | The Screening

Of course, this was the most gratifying part, the culmination of the ride: the reward, the dessert. I know that in your country that doesn't mean much, but I am French, and when you are a French kid, if you misbehave, the worst punishment is being deprived of dessert. Or it was. It's kinda old-fashioned, I guess. Anyhow, dessert is a good way to think of this ultimate phase. As above, its prospect helps motivate the troops to reach for the finish line, even when their energy reaches a low ebb.

And it never failed. For the simple reason that the actual quality of the film has nothing to do with the enjoyment it delivers. It's the experience that is responsible for it. As often as I could, I would watch the screenings with each film's group. Seated in the front row, most of the time looking backward toward the hilarious, embarrassed, and satisfied faces. Maybe my presence altered some viewings, as if they feared my so-called professional eye. But they would have been instantly reassured if they had seen my miserable, drunken, and self-aware performance in *Eliot's Midlife Crisis or How to Kill a Man in 10 Days*. That day, my hair was the longest it had been in years—as it is when I see myself in a dream—and I had the great idea to blow-dry it in my son's fashion. I didn't bother to check myself in a mirror, and so I discovered my "Claude François" hairdo only as we screened our film. Moreover, I had, for the entire shooting, a little black thing stuck on the right side of my nose. Of course nobody bothered to alert me. So this mooch is stuck to my face for eternity. Anyhow, the alcohol had numbed my senses at that point, so nothing mattered and I totally enjoyed our screening. Everything felt funny and rewarding. The werewolf transformation was perfect: a simple cut. A masterpiece. Everyone from the team was exhilarated.

The next day, when other friends came to see the filming and asked to watch our production, it was another story. It was merely funny and definitely *bâclé*. I mean, everybody else was good: Tim was great, he was perfectly integrated in the team, despite his size; but I would not put the film in my show reel. I am not disappointed by this. It actually makes my point. The protocol was working because of the fun and the social activity it provided and nothing else.

Despite mixed (terrible) reviews, the exhibition was a great success. All the participants, whether they were seeking a learning experience, new people to meet, or just two hours of entertainment, walked away fulfilled, and everyone was sad when we had to tear down the whole installation.

One reviewer who was especially condescending had come to the gallery and followed a group for the whole process except the screening. He had to go somewhere else. He came back the next day and watched another film on his own. Later he mocked it. I don't think he should have been allowed to look at it like this. It was not made for him, and he criticized it like someone who would break into someone's house, fiddle with his family pictures, and then publicly criticize their artistic value. Thinking back on it, only one willing to take the ride as a participant should have been allowed to see their movie, and no one else. We shouldn't have let anyone else judge the ride without riding it. It's only fair.

In the end, all the sets were destroyed and Deitch Projects was emptied in less than forty-eight hours. Galleries in Brazil, Japan and England are planning to bring the exhibit to their countries. The art gallery in Japan couldn't afford to transport the whole exhibition so we suggested that the participants could build their own sets and the Japanese agreed. Even though the gallery installation was the closest thing to my original utopia, I felt that we could get closer to the original idea outside a gallery, in the normal world with normal people.

A month before the exhibit closed, I had moved from an East Village condo to a house in Brooklyn, on Orient Avenue, a tiny portion of road squeezed in between a small park and two gas stations. Who would be happy to move next to a gas station? A French person. For us, they are a nostalgic reminder of the big holiday break on the *autoroute du sud*. In those days, we would get a free *Lucky Luke* comic book for a fill-up. The downside of being surrounded by all this nostalgia was that the adjacent street, Metropolitan Avenue, has a never-ending collection of big trucks rolling by all day long. This is at least a reminder that Brooklyn still has some industrial function. On the other hand, we are surrounded by a fresh set of condos scouting for the next set of gentrifiers, to whom I unfortunately belong. There is nothing I can do about it: No matter where I move, I am gentrifying. This is depressing.

Nevertheless, the street has a special quality, thanks to the trees planted forty years ago by Tom, a World War II veteran and my new neighbor. His wife, Helen, an eighty-year-old dynamic and welcoming little lady, gave us direct access to the community. She is pretty much an activist; for instance, she fought to reduce the number of big trucks on the streets. Because she talks with people of all different generations and backgrounds, she creates harmony between all of the neighbors. I think she's able to do all this perhaps because she's been living here for so long and comes from an era where neighborhoods were different and people were less isolated in their homes.

Anyhow, we decided to try out the protocol on my new street in order to test its efficacy in the "real world," as we had attempted

in Passaic, before Jeffrey Deitch gave us shelter. Helen's presence was crucial to the film, both on set and behind the scenes. Plus, she took me and my friend Jean-Louis on a trip to Atlantic City.

For all the reasons mentioned above, Helen and Tom's house seemed like the logical starting point for the project. We asked her if she could invite a couple of their neighbors over one evening, so that we could explain the project to them and gauge their interest. When we arrived, there were just four neighbors in Helen's old dining room. So I introduced myself and started to give an explanation of the project. But every couple of minutes, another set of neighbors would trickle in and I would have to repeat the details of my project. I tried to vary the vocabulary and details each time for the people who had just heard it. And by repeating the idea several times, I began to have and then articulate new ideas for how to do the shoot. The response was overwhelmingly positive. We had expected a lot of resistance from the neighbors, but all of them acted as though they were just committing to a BBQ or dinner party: "Sure, just tell us when!" There were just two obstacles to overcome: shyness and family schedules. Dance, basketball, baseball, even soccer are the weekend landlords of families in America, but in this instance they were my enemies. But we managed by picking a date in the future and sticking to it. For the shy ones, I promised (I lied) they could just watch the whole process without participating. By the end of that meeting, we had ten people who were on board. A modest-size group, yet larger than the number of people who had committed to our aborted Passaic shoot.

I have but one regret, a small failure: Neither myself, Jordan, nor Helen could convince the family living across the street to let their children participate in the shoot. Louise, the woman across

the street, has three young grandsons who shave their heads every week, wear the same clothes as one another, and spend their days getting into and out of the family Ford Taurus under the supervision of Louise. "I don't want my kids on film," Louise repeatedly said. Even Helen, her friend, could not get Louise to trust us and participate in the activity. Yesterday I saw them all outside the gas station patiently waiting with excitement for their car to be washed, getting ready for the Puerto Rican Day Parade.

One important reason why my first attempt failed to bring the protocol to the city of Passaic was the overly ambitious schedule we had proposed: We were hoping to conduct the process over the course of a month, with a meeting every week. We later realized that this was clearly unrealistic, so this time everything would be done in a single afternoon. The two first meetings (Workshops One and Two) would happen in my living room, with a pizza break in between. I think that this was a key decision to the success of the project. Proof of this came in the form of the huge tropical storm with twenty-mile-per-hour winds and twenty-one inches of rainfall that came to overshadow our day. Realizing that the weather might create a miserable experience for the group, I suggested two options just before we started: "Either write the story now and shoot tomorrow, or finish the film today, even if it means that we shoot under pouring rain." The overwhelming majority went for the second option: Nobody wanted to come back to finish the film and see the result. Those are important points to remember for those who want to use the protocol with their own group.

Most of the participants were on time. Kenny Page, my favorite sweeping-truck driver, who had played the priest in *Be Kind Rewind*, had participated in all three versions of the Neighborhood Movie Club. He arrived with his friends two hours early. He used the time to bombard me with his numerous writing projects, stories concerning the rise of a street-sweeper-truck driver who turns into a toy maker. Street-sweeper-truck toys, that is. Kenny cannot accept the fact that the Neighborhood Movie Club is not about learning filmmaking. He is already in the middle of his professional shift, so I won't dare to discourage him.

Everybody squeezed into the living room. Thirty-five people in one room. We had started with ten people committed to the project. The street network conducted by Helen had been efficient, and she had managed to bring in more participants. After thanking them for their participation and giving the group a short introduction to the project, I stepped back. My job was done and I could just watch and study the possible loopholes of the protocol. The crowd primarily came from Orient Avenue, with about thirteen other people from Passaic. We weren't originally expecting that many Passaic denizens, but Kenny invited one of his friends, a theater director, who in turn invited a bunch of actors. The actors provided an interesting dynamic to the group. Most of them initially thought that it was some kind of audition, so they tried hard to impress. But as the workshop progressed, they realized that this was not an audition, so they lightened up a bit.

Talking with my neighbors after the experience, I found out

that Helen and some key people from Orient Avenue were displeased with the intrusion of the Passaic people. "We thought it was a project about OUR street, not for everyone," I heard. "It would have been more pure with only true neighbors." I am not sure how to interpret "pure." Maybe the way I convinced my neighbors to participate too much on the fact it was about our street. We are all neighbors and this film was for everyone, even though it took place on Orient Avenue. Please, welcome strangers to our street! And the Orient Avenue crew eventually did. "Yes, the Passaic folks were great, as great as the Orient people," they finally admitted. In fact, the one guy most in favor of the "pure" film is moving out in two weeks, so if we were to shoot the film after his move, would he become an Orient stranger? Of course not.

About seven kids were present as well. But I immediately saw a potential pitfall: There were too many people, so the kids would be bored and want to go home. I think the pizza-break announcement solved the problem. Which reminds me of a hike I went on with my son and his cousin in the French mountains. I kept them going by promising them pizza when we got to the destination. After one mile, the first "Are we past the middle?" popped out. "Not really, there are six more to come," I said. Luckily, they were too hungry to turn back, and the afternoon was a success.

Back to my living room: After the genre was established—it generally ends up being a comedy/action/horror film—the title *There's a Hand in My Soup* was uttered, and no one could beat it. One of the kids in the group brought a big plastic monster hand. This had a direct and obvious influence on this choice.

Then the story was created: There is a hand in my soup. A hand in the soup means there is a victim and a killer. So that's how it starts: A couple hear on the news that Richard Simmons, who was to be married on Orient Avenue, has disappeared. This part was a bit abstract for the younger crowd but very amusing for the adults.

At this point, I noticed how difficult it was going to be to give everyone a part due to the group's size. So I reminded the group that everyone must have at least one appearance in the film. This information immediately bent the story: Instead of casting single actors, everyone agreed to be cast in groups: the neighbors from House #1 and House #2, the kids playing in the street, Search Party #1, etc. Ultimately, those groups gathered together to organize more search parties, in which more people vanished; even children were not spared! But the bride has decided to have the wedding reception because it's paid for anyway. At the reception, the paranoia is thriving, who is the killer????

As they struggled to wrap up the story, I was worried that the kids would lose interest. Banking on the power of taste buds to lubricate the imagination, I announced, "There are thirteen pizzas waiting for you in the kitchen when the story is finished!" The solution for the end came from one of the kids: "The cook, the chef, is the killer, because he has his utensils and knives as weapons." One more time the truth comes from a child's mouth, and the ending was agreed on: The cook brings the soup to the party and

there is a dead hand inside. Bon appétit.

By the time of the pizza break, everybody was having so much fun that we had to try really hard to get them back for Workshop Two. We talked about this construction site in our garden that created a fault in my neighbor's house, so the work was stopped due to a one-million-dollar lawsuit. At this point, I was mostly the host. I had no role as a director or exhibition artist. The anxiety before shooting that generally leads me to insomnia and volatile bowel movements had been divided equally among the thirty-five participants. But for the sake of perfecting the protocol, I wanted to make sure everybody was having a good time. "You don't participate much," I said to this African-American lady who came from Passaic with Kenny. "Yes, I prefer to take it all in," she responded. "Exactly, that's why you have more interesting things to say." I tried to give her confidence. Anyway, later I saw her prominently in the final film and she looked amused, so I guess she did have a good time.

Of course, the main difference between the Deitch exhibition and the neighborhood shoot was that the wealth of preconceived locations, as well as the little tricks possible at Deitch, such as the car/train moving, etc., were not present on Orient Avenue. It seemed at first that it would make the whole project less appealing, but luckily that was not the case. Moreover, it kept people from feeling like they had to make something professional looking. It freed them even more.

As a reward for our good intentions, the storm had cleared up by the time we stepped outside to shoot. All the locations needed for *There's a Hand in My Soup* were within fifty yards of our neighborhood. I was cleaning up the pizzas at this point, so I followed the shooting effort through my kitchen window. Every technical difficulty was overcome with simplicity and humor. To have a radio newscaster announce the disappearance of Richard Simmons through a car radio, a group member would make the announcement behind the camera as the passengers pretended the sound was coming from the radio. As the shoot progressed, the group realized that they needed to somehow show a hand in a bowl of soup. There was a lot of discussion: Some thought they should break a bowl and have a hand stick through the hole. But no one really wanted to break their own bowl. So in the end they simply used the hand of one of the participants off camera. His hand would suddenly appear in the bowl where the imaginary soup was poured. This was a charming and rather realistic effect.

The nicest part of the day was seeing the group just hanging outside in the quiet street and slowly moving to the different locations to finish their shoot. The kids were used early in the shoot, so once they were done they would just start playing in the street, sword-fighting with sticks and playing tag.

Since there were so many people, only about a fourth of the group was actively involved in each scene, so little pockets of people formed along the street. Neighbors who hadn't met one another all laughed together, the Passaic folk interspersed through-out each of the groups. Helen would meander through each little

chat circle, always with a proud twinkle in her eye. Tom, her husband, who had to work that day (I suspect he was just being shy), stopped by for the shooting to show me the French-English dictionary he got in the war. Since everyone was actively making a fool of themselves, people weren't afraid to talk with other people. It almost worked better than liquor. At the end of each take, everyone in the group would applaud, creating a mini-celebration. It was simply a perfect afternoon in the street, just like it should always be. I wished the ghost of Jane Jacobs was around to see our achievement. She might have given this book a nice foreword.

The screening was up next, so I sent my friend Jean-Louis to buy some red wine to celebrate at the wrap party. But by the time he returned, people had watched the film, laughed at the perfect spots, applauded, and yelled at the end. I saw on their faces the same look I had seen in Passaic during *Be Kind Rewind* and at Deitch Projects: pride mixed with acceptance of the silliness involved, and a big smile. It was all over before we knew it, and perfectly on time: They had managed to simplify the shooting to meet the schedule and their Saturday duties. Jean-Louis looked confused and disappointed with his red wine. Luckily, the celebration had already continued in the form of a BBQ at a friend of one of the neighbors' house.

Oh, I forgot to mention that Orient Avenue was the location of Kate Winslet's house in *Eternal Sunshine of the Spotless Mind*. I had just moved to the same spot where, five years ago, I was shooting for nights and nights, and I had no idea until some neighbor revealed it to me. Pure coincidence. This is such a small world... Oops...

In conclusion, I don't think that bringing the protocol back to the street diminished the experience. Of course, one could argue that this street is not like the rest of the world. Each street, or district, is different, and there are a lot of places where people like the family across the street would only feel suspicion toward such a project. Film crews and the audiovisual industry in general don't have the support of everyone. Quite the contrary. But once more, this is not about making film. This is about making something for yourself, no matter your job or background, and stepping out of your home and being free of all the corporations reaching out to your brain through all the technological orifices, TV, radio, telephone, Internet, to convince you that the outside is not safe. It's about a living, physical community.

I am printing a revised version of the protocol in the back of this book. Anyone can Xerox it and use it to start his own town movie. I hope this book is a decent recipe to encourage anyone to follow the experience. I don't think the film coming out of this should end up on the Web. It should remain on a physical device, whether tape or DVD. Don't let any corporation sponsor your effort if you are following the protocol. You don't need their money. Instead, you can write to my office (care of my web site www.michelgondry.com) with a proposal, which just needs to have a locale (private or not), a list of participants, and their e-mail if they have one. In exchange, we will send you a digital camera (free) to shoot your project. We shall keep in touch. Later, if a good number of groups everywhere in the world make their own film, we could exchange them, through the old-fashioned mail, instead of the www, and create a network bypassing all possible censorship.

Good luck.

WELCOME TO THE NEIGHBORHOOD MOVIE CLUB

During the next few hours, you and your group will plan, shoot, and screen a film in your neighborhood. It's important that the group read and follow all the instructions. Have fun and don't worry about making mistakes, it's all part of the fun. Remember that imperfection is your ally.

Stage One

▸ During this time, your group will create a basic storyline for the film using Instruction Sheet A.

▸ The group must first vote on a cameraperson, who will be in charge of leading the discussion and directing the camerawork during the shoot. But most important, the cameraperson is responsible for the safety of the camera. The group must also choose a timekeeper, who should remind the group of the time every 15 minutes.

▸ At the end of the 45-minute period, your group should have established the following ideas: genre, title, and storyline.

▸ These parts of your story will be decided with a democratic vote, allowing everyone to have a say in the film's creation.

▸ When choosing the genre, title, and story, the cameraperson will ask the group for suggestions and write each of them on the board. When all of the group's ideas are written on the board, the group will choose one by voting. Members may vote as many times as they like.

*NOTE A good idea would be to pick two titles, genres, etc. and combine them to create a more imaginative film.

▸ All group members are expected to contribute suggestions and quiet members should be encouraged to talk.

▸ Please begin to follow the steps on Instruction Sheet A.

Time Limit: 45 Minutes.

Instruction Sheet A

#1 Choose Cameraperson
As a group, vote on who should be the cameraperson. It is crucial that the camera person be vocal, assertive, and confident. They must never appear in front of the camera. CHOOSE WISELY!

#2 Choose Timekeeper
As a group, vote on who should keep track of time. That person must remind the group of how much time is left every 15 minutes.

#3 Propose Genre
Propose different genres. The cameraperson will put each genre on the board. When all of the suggestions have been written, choose one by voting, remember that you can combine multiple genres. Each member can vote as many times as they would like.

***NOTE** Groups are also encouraged to use personal experiences as inspiration for their films.

#4 Propose Title
Everyone is invited to suggest a title. The cameraperson should write the titles on the board. It's OK if the group likes multiple title because you can combine titles.

#5 Choose Title
The group must vote on which title(s) to use. Once the group has voted on a title, the cameraperson must erase everything on the board except for the chosen title.

#6 Propose Various Storylines
The group should talk about their ideas for the film's storyline. The cameraperson will put all the ideas on the board. The group should vote on which ideas to keep. The group should then take all the ideas they have chosen and turn them into a complete storyline.

***NOTE** Your storyline must be from 8 to 12 sentences. Don't worry about who will play what part or how to shoot certain parts, instead, focus on creating a complete storyline with a beginning, middle, and end.

#7 Write Your Storyline
Once your group has decided on a final storyline, the cameraperson should select an assistant to write it down.

***NOTE** Your storyline should be concise and clear. Make sure that anyone could understand it. It should be written as though you were pitching your movie to a friend.

#8 Read Storyline Out Loud
The camera person should read the storyline out loud to the group to make sure that everyone is happy with the final version. Once the group is finished with the storyline, they should move on to Stage Two.

#9 Move on to Stage Two

Stage Two

▶ This stage provides your group with a storyline grid to help plan out each scene. The grid should act as a detailed map for the group, containing all the important information to complete the shoot.

▶ Once again, the cameraperson will discuss ideas with the group. In the interest of time, one group member should be in charge of writing on the grid, while other members should create narrative cards.

▶ Please read the description of each column before you fill in the corresponding box.

▶ The following will be decided at this point: storyline, night/day setting, set/location, action, character names, roles, accessories/costumes, narrative cards.

*NOTE A well-balanced grid is a well-directed movie.

▶ Feel free to utilize all the props your group brought, locations around the area, and the craft materials to make anything that you might need.

▶ Once the group has completed the grid, they should begin filming.

Time limit: 45 minutes

How to Use the Grid

▶ Storyline: Each of the 8-12 sentences of your storyline from Stage One should be individually placed into each of the storyline boxes. Each sentence should represent one scene. If a long sentence requires more space, you can divide it into multiple boxes.

*NOTE The grid must be filled out HORIZONTALLY.

▶ Day/Night: Determine the time of day for the scene.

▶ Set/Location: Choose a location in your neighborhood to shoot each scene, but remember that you only have an hour to shoot so it must not be too far away.

▶ Action: Provide a more detailed description of the action and details within the scene. The scene MUST reflect the sentence that it is illustrating.

▶ Character Names: Determine which characters will appear in each scene. Be imaginative when choosing names.

▶ Name of Group Member Playing Role: The group must decide which members will play each role. Members cannot choose their own role, instead they can only propose other members for roles. Any conflicts or overlapping roles can quickly be resolved by a vote. Avoid egocentricity and stubborn attitudes. Every member must have a role and appear on camera in at least one scene. If a member is not proposed for a role, they may create one for themselves and the story must be changed to include the new character.

▶ Accessories/Costumes: Decide which of your group's costumes and props will be used for each scene.

▶ Narrative Cards: These cards are used to create scene transitions or provide important information for the scene. These cards are optional but may be useful. Here are a few examples: "The next day," "In a small town," or "Georgina lost her mind at this point."